IMAGES
of America

DULUTH

MINNESOTA

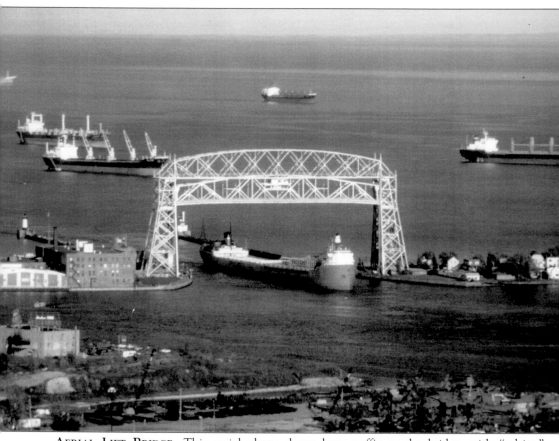

AERIAL LIFT BRIDGE. This aerial photo shows busy traffic at the bridge, with "salties," ocean-going vessels which have come through the St. Lawrence Seaway, waiting to enter the Duluth Harbor. The large, longer vessel entering the harbor is a "laker," a type of boat which carried ore, grain, coal, and other products between ports within the Great Lakes.

COVER PHOTO: A scene in Lincoln Park about 1900.

IMAGES
of America

DULUTH
MINNESOTA

Sheldon T. Aubut and Maryanne C. Norton

ARCADIA
PUBLISHING

Published by Arcadia Publishing
Charleston, South Carolina

Printed in the United States of America

Library of Congress Catalog Card Number: 2001091001

For all general information contact Arcadia Publishing at:
Telephone 843-853-2070
Fax 843-853-0044
E-mail sales@arcadiapublishing.com
For customer service and orders:
Toll-Free 1-888-313-2665

Visit us on the Internet at www.arcadiapublishing.com

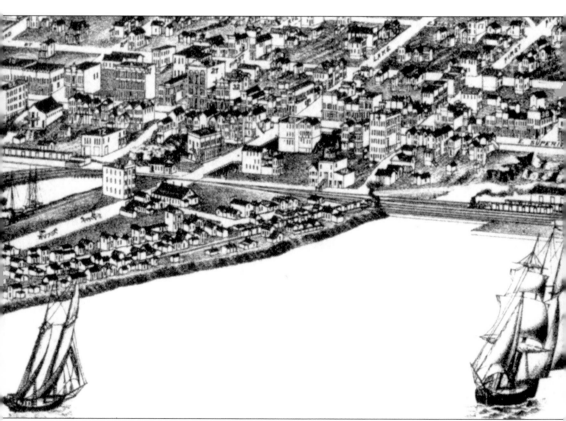

MAP OF BIRD'S-EYE VIEW OF DOWNTOWN DULUTH, 1883.

CONTENTS

ACKNOWLEDGMENTS

The authors would like to express their gratitude to the following people who helped make this book possible:

--The staff of the Duluth Public Library for their enthusiasm and for allowing access to books, files, and slides in the library's collections; most of the photos in this book are from the library's extensive collection of early Duluth publications. Wayne Gatlin, Bob Swanfeld, Beverly Truscott, and Mary Ellen Owens for use of postcards and photos from their collections; Pat Maus of the Northeast Minnesota Historical Center who helped find answers to some of the difficult research challenges; the staff of the City of Duluth Building Inspection Office for their help in unraveling the histories of Duluth's buildings; and Eric Ringsred for years of dedication to Duluth's historic buildings. He has inspired us in our personal commitment and enthusiasm for the wonderful historic resources our city has to offer. Patti Goffin and Daniel Norton whose support and love helped us through this project.

INTRODUCTION

This book is intended as a celebration of Duluth's past: its talented and industrious people, its beautiful natural environment, and its architecturally significant structures. There are few cities in this country with a lake such as Superior at its doorstep, and steep hills where rivers and creeks tumble through canyons and over rock formations to reach the lake. Those natural features convinced early surveyors and settlers that this city could be the next Chicago, or perhaps an even more important metropolis.

The ideal location for shipping timber, grain, iron ore from Minnesota's iron ranges, and other bulk products brought great wealth to Duluth. It was often said Duluth had more millionaires per capita than any other city in the United States. That wealth produced the mansions in the East End and the spectacular architecture which talented Duluth and nationally known architects designed from the 1880s until 1920. Much of that architecture has disappeared, victims of "progress," urban renewal, and developers who disregarded the arts of the past. Although much has disappeared, there are still many significant sites in Duluth which one may still visit.

We have attempted in this book to showcase those beautiful commercial buildings, homes, bridges, and the people who created them. It is not possible to picture all the great architecture, past and present, in a volume this size, and it has been difficult to choose. We hope the reader will forgive us if favorite architectural gems are not included. Research on some early buildings has been difficult, and we have had to evaluate conflicting information and to choose what seemed the most reasonable and reliable.

It is our hope that this book rekindles memories and appreciation for the treasures of this wonderful city.

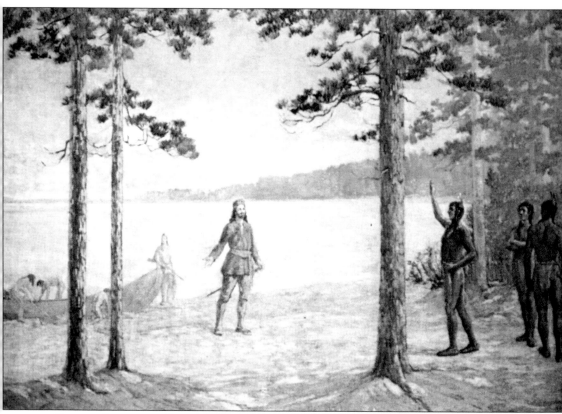

DANIEL GREYSOLON SIEUR DU LHUT, 1640–1710. Daniel Greysolon Sieur du Lhut was born at Saint-Germain-en-Laye, France, about 1640, and died at Montreal on February 26, 1710. He was a minor aristocrat who joined the French army and rose to become a gendarme of the King's Guard. In 1674, he joined other members of his family, including his brother La Tourette, at Montreal. After several short expeditions he was directed to explore the western lands. In 1679, du Lhut took possession of the Sioux territories in the name of the King of France. He was also sent to make peace between Ojibwe, Sioux, Cree, and other tribes. In his explorations of the Lake Superior area, on June 27, 1679, he landed on Minnesota Point at "Little Portage," where the Duluth Canal was later dug. After exploring the region, he returned to Duluth on September 15, 1679, and negotiated a treaty between the Sioux, Ojibwe, and the French, and sealed it by marrying couples between the tribes. Du Lhut is credited with opening up, and claiming for France, the area from Michigan to Manitoba, including the Lake Superior region. For 30 years he explored the region and established many forts. He is also credited with rescuing Father Hennepin when the Sioux had him prisoner. At a meeting of early residents in 1856, the name Duluth was chosen to honor Daniel Graysolon Sieur du Lhut. The photo is of a color painting by Clarence Rosenkrantz.

One

EARLY DULUTH HISTORY

OJIBWE PEOPLE ON MINNESOTA POINT. The Ojibwe (or Anishinaabe) people originally lived in Quebec, Ontario, and New York. As the French and English pushed the Six Nations of the Iroquois Confederacy, they in turn pushed the Ojibwe west to Wisconsin and Minnesota, and as far north as Manitoba, although the migration may have started before Europeans landed in North America. Prior to the 1600s, the Sioux inhabited the area around Duluth. During this period the Sioux and Ojibwe fought many battles, and eventually the Sioux were pushed to the plains. About the time that du Lhut arrived in the area there were several native villages in what was later to be Duluth. It was recorded that he was met by Ojibwe people when he landed at "Little Portage," where the Aerial Lift Bridge is now.

ASTOR TRADING POST AT FOND DU LAC. The first trading post at Fond du Lac is believed to have been built by English fur traders in 1793. John Jacob Astor's American Fur Company took over the post in 1809, and later built log buildings, including warehouses, boat yard, clerk's house, and quarters for voyageurs. Trade declined in the 1830s, and the American Fur Company collapsed financially in 1842. The post closed about 1850. Some buildings were still standing in the 1890s, but have since all disappeared.

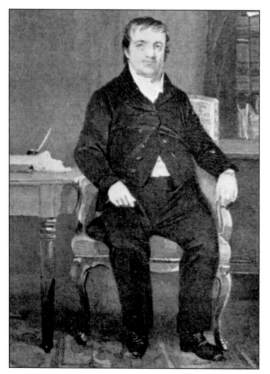

JOHN JACOB ASTOR. John Jacob Astor was born in Germany, and as a young man left home to join his brother in London. While there he learned English and took in all the information he could on the rebellious colonies. In 1784, he moved to New York City and went to work for a furrier, became a fur trader, and built his fortune in the fur trade, becoming America's first millionaire. He founded the American Fur Company in 1808, and through it had almost a monopoly of the trade in the United States.

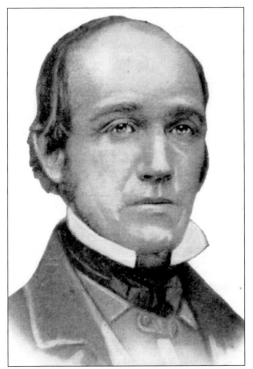

EDMUND F. AND CATHERINE ELY. Missionary Rev. Edmund F. Ely was sent to Fond du Lac in 1833 to preach and to teach the Ojibwe living near the Astor Trading Post. He built the first school and taught grammar, arithmetic, and catechism. In 1835, he married Catherine Bissell, also a missionary teacher. Ely helped establish the first school in the region, and was involved in development of town sites in the 1850s. He left the area about 1860.

PETER J. PETERSON HOUSE, 13328 WEST THIRD STREET—FOND DU LAC. Very little is known about the Peterson family who lived in this 1867 Duluth house, probably the oldest residence in the city. When it was built, Fond du Lac was a separate town which was located around the American Fur Trade Post. It's likely that Peter Peterson came to Fond du Lac in the 1850s to work in the fur trade. His wife's name may have been Joanna. The Peterson house has changed over the years, but is still standing.

GEORGE STUNTZ. Stuntz moved across the bay from Superior, Wisconsin, in 1852 to conduct a federal survey of the area. He was probably Duluth's first permanent settler, building a house, trading post, dock, and warehouse near the end of Minnesota Point. He attended the 1854 treaty at La Pointe, Wisconsin, where the land encompassing Duluth was sold by the Ojibwes to the federal government. Stuntz was a farmer, sawmill operator, and served as sheriff. He cleared the Vermillion Trail from Duluth to Lake Vermillion, and was instrumental in the discovery of gold, silver, and iron ore in the region.

MERRITT FAMILY. Lewis Merritt came to the area and settled in Oneota in 1855 with one son. The following year his wife Hepzibah and the rest of the family came. They were early residents of the Oneota neighborhood in the western part of Duluth and constructed a hotel and established a church there. Later the Merritt brothers developed the Mesabi Iron Ore Range, though they eventually lost control of the mines to John D. Rockefeller. They were surveyors, miners, geologists, and businessmen who left their lasting mark on Duluth and Northern Minnesota.

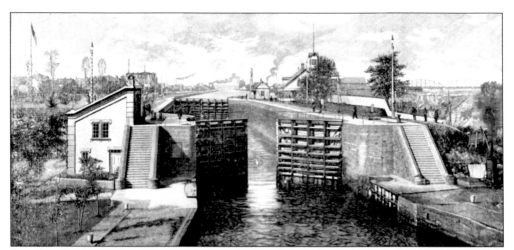

Soo Locks, Sault St. Marie, Michigan. The first lock was built and opened in 1855. It allowed ships to enter Lake Superior from the east without portaging. This encouraged Great Lakes shipping and enabled Duluth to become a major shipping port. It also brought immigrants to the Duluth area. Grain, coal, and later iron ore were shipped to the East.

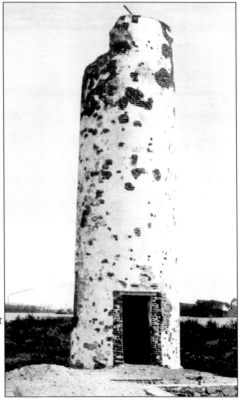

Minnesota Point Lighthouse, End of Minnesota Point. Duluth's oldest surviving structure is located about 1.5 miles from the parking lot near Sky Harbor Airport. It can be reached by walking through a pine forest or along the lakeshore. When completed in 1858, the red brick lighthouse had a cover of lime and cement mortar, and stood 50 feet tall with a French-made lens lighted with kerosene. There was a small brick light keeper's home next to the tower. Today the crumbling tower's ruins are about 30 feet high, and the mortar has mostly peeled off. The lighthouse marks the "zero" point for all early surveys of Lake Superior. In 1878, the lens was moved to the Superior Bay entry and the light keeper's home and tower were abandoned. The lighthouse ruins are listed on the National Register of Historic Places.

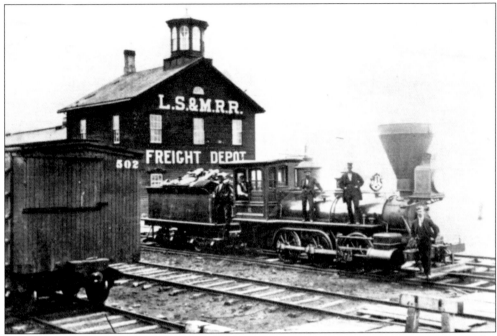

LAKE SUPERIOR AND MISSISSIPPI RAILWAY DEPOT AND ENGINE ON THE LAKE SHORE. This photo was taken about the time the first locomotive whistle was heard in Duluth, when a passenger train from St. Paul arrived late at night on August 1, 1870. The engine in the photo which brought the train to Duluth is pictured at the depot of the Lake Superior and Mississippi Railway, located at the lake shore at about Fourth Avenue East.

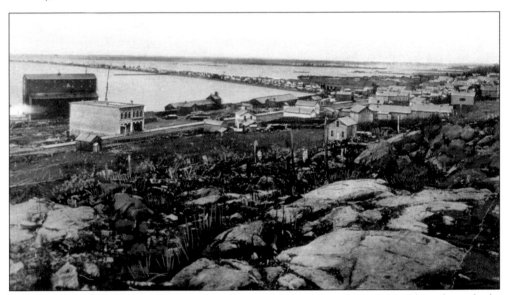

DULUTH IN 1871. The east side of Duluth was undeveloped in 1871. This photo looks southwest from about Eighth Avenue East. Elevator A on the lakeshore was built in 1870, and burned in 1881. In front of Elevator A is Branch's Hall, the first brick building in Duluth, also built in 1870. It was razed in the 1980s for the construction of Interstate 35. The wood pier of the canal is visible along Minnesota Point where the canal had just been completed.

DIGGING THE SHIP CANAL. The "Little Portage," known to Daniel Greysolon Sieur de Lhut when he landed on Minnesota Point in 1679, was the logical spot for a canal, because it was the narrowest spot on the peninsula, and there was already a creek at that location. The Ojibwe occupied this area prior to the 1850s, and no one could cross the point without their permission, but with the LaPointe Treaty of 1854 they gave up their right to the point. Until the canal was dug, all lake traffic had to enter the Superior harbor between the ends of Minnesota and Wisconsin Points. Dredging for the canal began in 1870, but stopped for the winter. Superior, Wisconsin residents were concerned that the water levels in the bay would change if a canal were put in, and Duluth became the port. They asked the United States War Department for an injunction to stop the digging. When word came that the injunction was on its way, the dredge *Ishpeming* worked around the clock, and some citizens even pitched in with picks and shovels. As many as 50 people dug, while up to 300 people looked on and just a few hours before the injunction reached Duluth, on June 11, 1871, water flowed through the canal, widening it with its force. The small, ocean-going boat *Fero* traversed the canal just as George Stuntz showed up with the injunction, but he was too late. An ocean-going boat passing through the canal immediately made it a "navigable waterway," and the injunction had no effect. The original piers were built of timbers but were replaced with concrete in 1898 when the canal was widened.

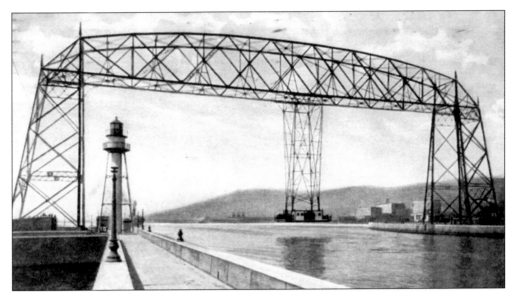

AERIAL LIFT BRIDGE. When the canal was dug in 1871, it caused the south portion of Minnesota Point to become an island. Early attempts to cross the canal included a ferry rowboat, a steam ferry, and planks laid across the ice in winter. Duluth City Engineer Thomas F. McGilvray modeled the original bridge, built in 1905, after a similar bridge in Rouen, France. It had a vertical steel structure on each side, with a truss across the top. A gondola car hung below the truss to carry passengers, streetcars, and wagons over the canal. By 1929, increased vehicular traffic caused the city to explore a faster and easier method of crossing the canal. Structural engineer C.P.A. Turner designed the true "lift" bridge, still in use today.

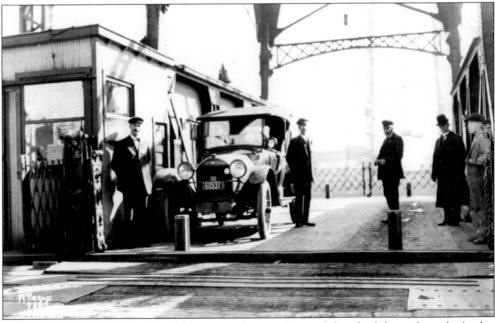

GONDOLA WITH CAR. This 1919 photo was taken on the gondola, which hung from the bridge over the canal and made trips across the water in about 10 minutes. The men in the photo are passengers and bridge workers.

Two

MINNESOTA POINT

Minnesota Point extends east from downtown Duluth towards Wisconsin and the Superior entrance to the St. Louis River harbor. The first pioneers who came in the 1850s settled on this narrow, sandy isthmus where Anishinaabe (Objibwe) natives lived. As the general population moved to the harbor, up the hillsides, and along the lake shore, Minnesota Point became an industrial area northwest of the canal and a residential neighborhood and vacation site across the canal, along the beaches and in the pine forest. In recent years the area northwest of the canal has been called Canal Park and has filled with hotels, restaurants, and gift shops.

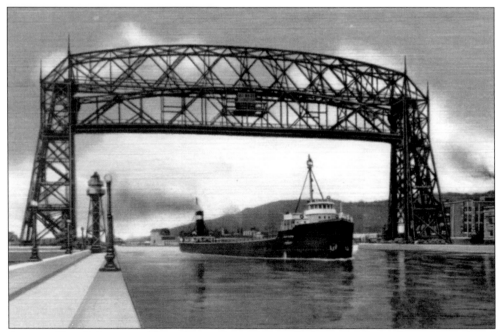

AERIAL "LIFT" BRIDGE. This photo of the Aerial Bridge was taken after it was altered to become a "lift" bridge in 1929. An ore boat is seen leaving the harbor headed for steel producing ports on the Great Lakes. The control house for bridge operators can be seen in the center of the lift section.

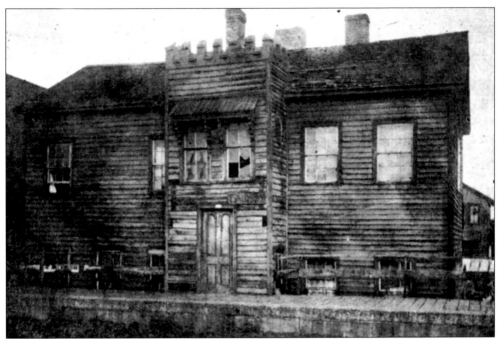

JEFFERSON HOUSE, 430 LAKE AVENUE SOUTH. Robert Jefferson built this frame house in 1855. It was the first two-story building in Duluth, and Jefferson ran it as a hotel for early settlers and visitors. He did surveying and platting of the Town of Duluth in 1856. After Jefferson, Judge John Carey moved in, about 1865, and found himself a hotel proprietor. Dr. Thomas Preston Foster also lived in the Jefferson house. He founded the first daily newspaper in Duluth, the *Minnesotian*, which made its debut on April 24, 1869. This early house/hotel survived until the 1920s when it was demolished.

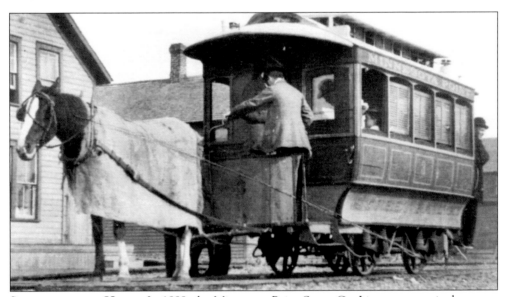

STREETCAR WITH HORSE. In 1888, the Minnesota Point Street Car Line was organized to serve residents and businesses on five miles of Park Point. The tracks were narrow gauge, and horses pulled the cars with boards laid between the rails to prevent the horses from sinking into the sand.

THE BETHEL, 245 SOUTH LAKE AVENUE. The Bethel Association was founded in 1873 as a missionary society to serve the sailors whose ships visited Duluth. Later it expanded its services to loggers, miners, railway men, and their families. Rev. Dr. Charles C. Salter became chaplain in 1886, and raised all the funds for the building built in 1889. It had a restaurant and sleeping quarters, and was also a refuge for the homeless. This building was demolished in 1948, although the Bethel still exists as a social services agency today.

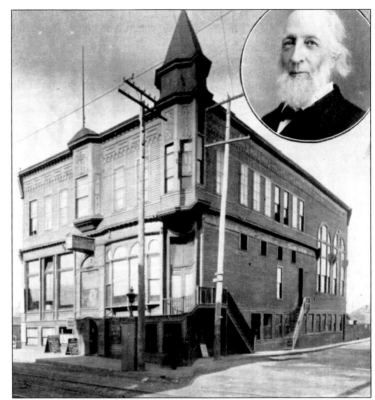

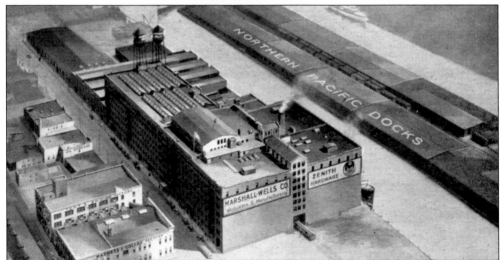

MARSHALL-WELLS PLANT AND WAREHOUSE, 325 SOUTH LAKE AVENUE. Albert Marshall purchased an early wholesale hardware business in 1893, named it Marshall-Wells, and built a warehouse on South Fifth Avenue West. The firm distributed hardware throughout Minnesota, neighboring states, and Canada, and also manufactured tools, paint, and appliances. By 1900, growth caused a new building on Lake Avenue, built in two sections straddling railway tracks. In 1910, Marshall-Wells was the third largest wholesale hardware business in the world. Marshall-Wells was liquidated in the late 1950s, and the buildings were sold in 1958. A stone shield with insignia still hangs above the entrance.

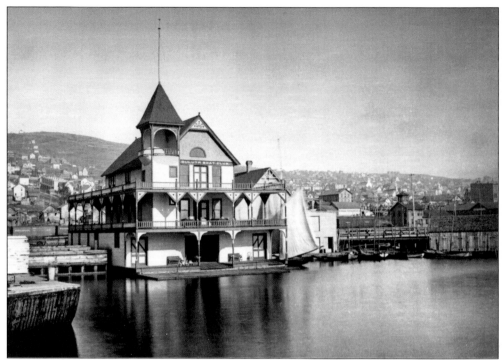

THE FIRST BOAT CLUB. Duluth Boat Club was organized in 1886 with 11 members. They built a clubhouse on about Seventh Avenue West and the bay front. Membership grew rapidly, and the main activities of the organization were recreational and competitive rowing.

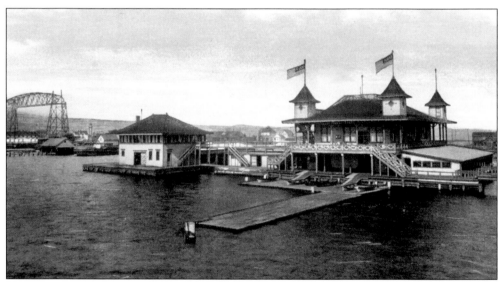

THE SECOND BOAT CLUB. By the turn of the century, water sports were so popular that a larger clubhouse was needed. It was built on the harbor side of Minnesota Point at 10th Avenue. This was the social center of Duluth for many years. It had 178 rowboats and canoes, and a flotilla of sailboats. Duluth rowers won 20 national championships between 1911 and 1923, as well as hosting the national races in 1916. Because of lack of interest and low financial backing, the club was forced to fold in 1926.

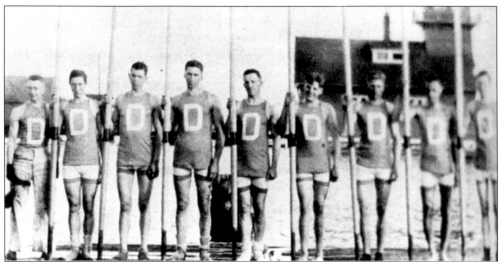

DULUTH BOAT CLUB CHAMPIONS. Duluth's rowing teams had limited success in competitions until James Ten Eyck Jr. became the coach in 1911. The team began to win races in the Nationals, and in 1914 they won five races at the Nationals in Philadelphia. The photo is the 1914 team of whom a Philadelphian newspaper said, "The nation can be proud of such a body of men."

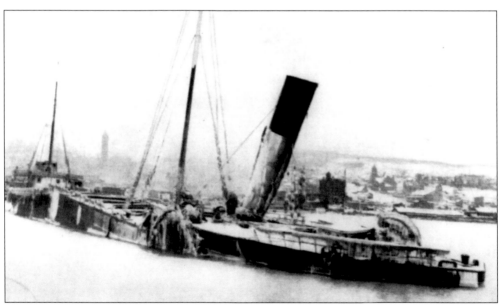

MATAAFA SHIPWRECK. Lake Superior, the largest of the Great Lakes, is capable of whipping up storms which threaten vessels and human lives, and one of the worst storms was on November 27 and 28, 1905. A blizzard with rain, snow, and 60 mile an hour winds battered the north shore for 13 hours. The iron ore carrier *Mataafa* left Duluth during the storm but turned back before it reached Two Harbors. As a crowd watched from shore, the vessel attempted to enter the ship canal, but struck bottom, swung around, hit the north pier and broke almost in half. It was then swept onto rocks near the beach. Rescue boats struggling to save the 24-man crew were unable to reach the carrier until the morning of November 29. Nine men had frozen to death, but fifteen were still alive. At least seven other steamers or barges were lost along Minnesota's north shore in the November 1905 storm.

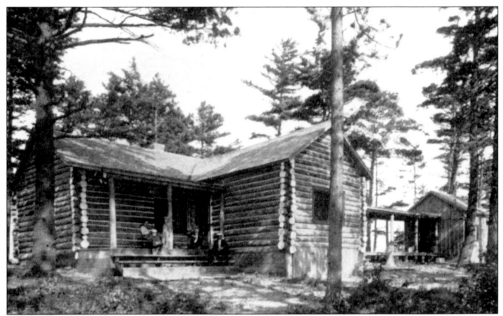

SARGENT CABIN. Early in its history, Duluth was dubbed the "air-conditioned city" by a New York City newspaper because of its moderated summer temperatures. It was also knows as a haven for hay fever sufferers. Many Duluthians and persons from other places built summer residences on Minnesota Point. This is the log cabin of William Sargent, son of George Sargent who was Jay Cooke's representative in Duluth.

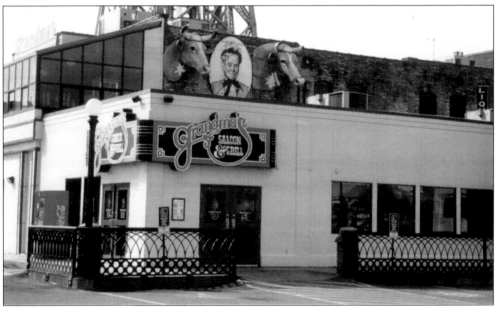

GRANDMA'S SALOON & DELI, 522 LAKE AVENUE SOUTH. This building has been a warehouse, a bar, and a "house of ill-repute," which legend says was operated by Rosa Brochi, who came to Duluth in 1869. In 1976, the restaurant opened and has lent its name to one of Duluth's largest annual events, Grandma's Marathon, which is run in June of each year, from Two Harbors to Duluth, ending at Grandma's, located next to the Aerial Lift Bridge.

THE LAST SURVIVOR, END OF CANAL PARK DRIVE NEAR MARINE MUSEUM. At age 17, in 1864, Albert Woolson enlisted in the First Minnesota Heavy Artillery Regiment of the Union Army. He served as the Regiment's drummer boy, and was the last survivor of the Union Army, dying in Duluth in 1956 at the age of 109. His funeral at the Duluth Armory was the largest ever in Duluth. Many United States Army officials and representatives from Washington attended. A bronze statue by Arvad Fairbanks was installed in Gettysburg, and in 1985 a replica was put in Canal Park. Woolson wears his uniform with his medals and his G.A.R. hat is by his side.

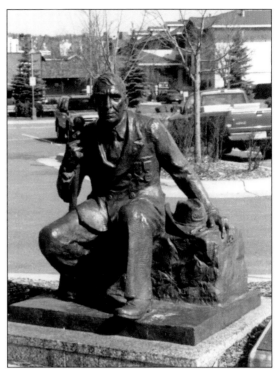

LAKEWALK—ALONG THE NORTH SHORE OF LAKE SUPERIOR. Beginning at the canal, Duluth's Lakewalk follows the shore of Lake Superior to about 32nd Avenue East. Designed by Kent Worley and opened in 1989, the boardwalk and paths pass public art works, historic plaques, Leif Ericson Park, the Rose Garden, and many landmarks. The vistas along the shore are spectacular, and one can watch ships and ore boats traverse the canal.

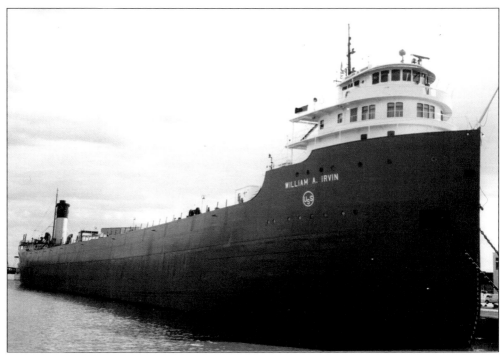

WILLIAM IRVIN ORE BOAT, 350 HARBOR DRIVE. The *Irvin* was the first Great Lakes major bulk freighter built after the depression, in 1938. This vessel was the flagship of the United States Steel Great Lakes Fleet until retirement in 1978. Now permanently berthed at Minnesota Slip, she is listed on the National Register of Historic Places and is open seasonally for tours.

DEWITT-SEITZ BUILDING, 394 LAKE AVENUE SOUTH. Built in 1909 and designed by Duluth architect John J. Wangenstein in the commercial style of architecture, its original use was as a mattress factory and furniture warehouse, with mattresses being manufactured here until 1983. Restoration began in 1985, and it now houses shops, restaurants, and offices, and is listed on the National Register of Historic Places.

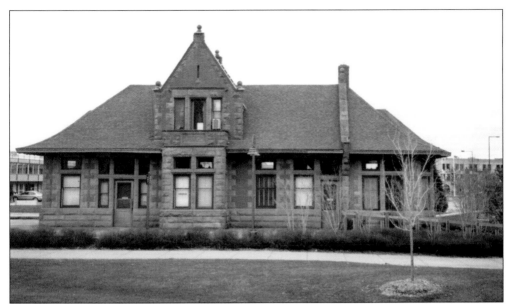

ENDION DEPOT, 100 LAKE PLACE DRIVE. Originally a train depot at 15th and Water Street, it had to be moved for development of Interstate 35 through Duluth. It was built in 1899 to serve the Endion neighborhood as a passenger and freight station for the Duluth and Iron Range Railway. The last passenger train left the depot in 1961, and the last freight train in 1978. Architects were Duluthians I. Vernon Hill and Gearhard A. Tenbusch. Built of brick and sandstone, it is listed on the National Register of Historic Places. In 1986, the building was moved to Canal Park and now serves as the Duluth Convention and Visitors' Bureau offices.

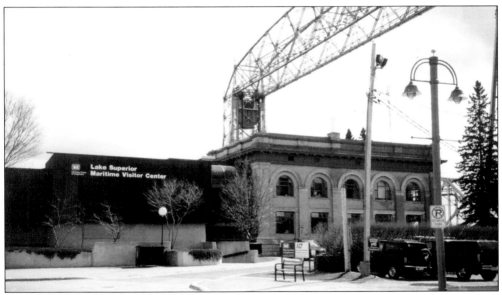

CORPS OF ENGINEERS AND MARINE MUSEUM, 600 SOUTH LAKE AVENUE. The original United States Army Corps of Engineers building was built in 1905 to aid in the construction of the Aerial Lift Bridge. Wallace Welbanks and William Bray were the architects. There were additions in 1941 and 1973, the latter being the Marine Museum which celebrates the history of the Great Lakes.

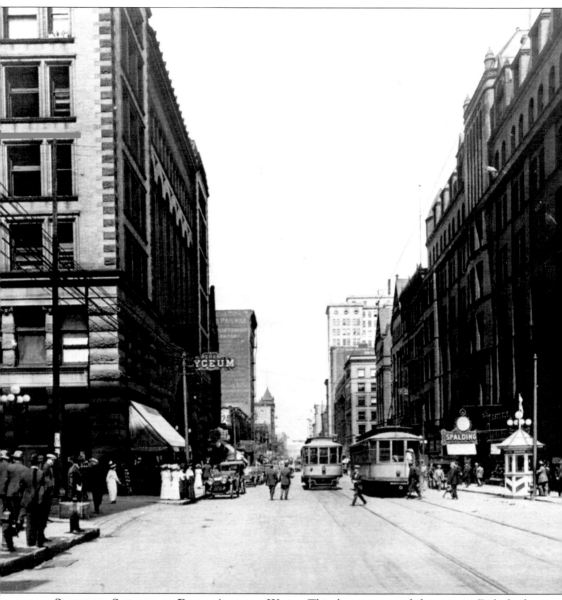

SUPERIOR STREET AT FIFTH AVENUE WEST. This busy scene of downtown Duluth dates to about 1910. The Lyceum Theater is on the left, and the Spalding Hotel on the right. Streetcars, automobiles, and pedestrians indicate a lively business community for Duluth's 78,000 citizens.

Three

WEST DOWNTOWN

As early settlers seeking jobs or adventure came to Duluth in the 1860s and 1870s, Superior Street became the business district with two-story, wood, false-fronted buildings lining the muddy and unpaved street. Families usually lived on the second floor of these structures. Most of the early buildings were west of Lake Avenue, the roadway from Minnesota Point, and the division between east and west Duluth.

After several fires and the discovery of sandstone formations in Fond du Lac, the wood structures were replaced with larger, architecturally styled buildings which served as hotels, retail establishments, saloons, restaurants, and office buildings. Gradually, First and Second Streets were developed as part of the commercial district. Most of the financial institutions located west of Lake Avenue on Superior Street are still present there.

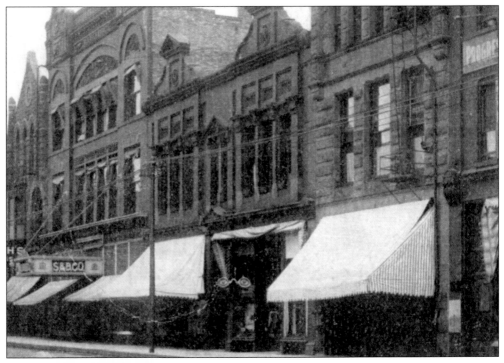

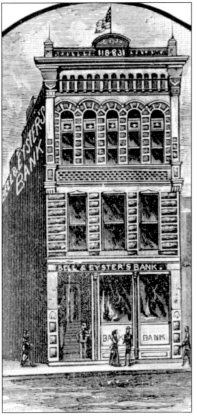

WEST SUPERIOR STREET 1–13. These brownstone buildings were constructed between 1883 and 1886. Most were designed by George Wirth or Oliver Traphagen in the Richardsonian Romanesque Revival style. From the right, the Progressive Medical Association was in the Norris Block where Camille Poirier had an early store for boots and shoes. Next, with the awning is the Bell and Eyster Bank. Next-door is the Norris-McDougall Block. The tall building with the S&B sign is Silberstein and Bondy Dry Goods Store, located here from 1884 to the mid-1930s. The building on the far left is the Wirth Building. All are extant, although Norris McDougal and Silberstein-Bondy have new facades.

BELL AND EYSTER BANK, 3 WEST SUPERIOR STREET. In 1877, Henry H. Bell and William Eyster organized the Bell and Eyster Bank, one of the Duluth's earliest private banks. They built their brownstone bank building in 1883. George Wirth of St. Paul was the architect. When it opened, the *Duluth Daily Tribune* declared it "the handsomest on Superior." The 1883 date, carved in the brownstone near the roofline, can still be seen. Bell and Eyster's bank failed in 1890, and by 1893, the State Bank of Duluth occupied the building.

ALEXANDER MILES. Alexander Miles was an unusual figure in the early history of Duluth. He was an African American who was born in Ohio, and came to Duluth in the 1870s where he worked as a barber. By 1883, he was involved in real estate and soon after built a commercial building on Superior Street and six rental houses on West Fourth Street. He was awarded a patent for a new elevator design in 1887, and was the only black member of the Duluth Chamber of Commerce.

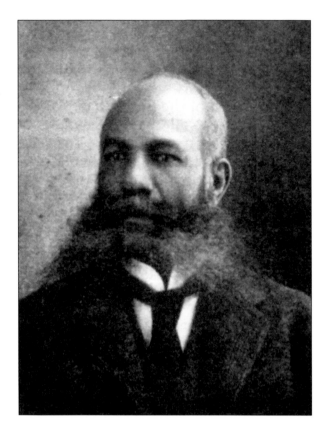

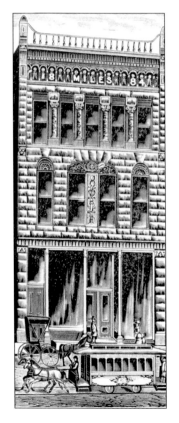

MILES BLOCK, 19 WEST SUPERIOR STREET. The Miles Block was of brownstone with Vermont marble columns and was decorated with carved faces and the date and name. Alexander Miles built this building in 1884, and it was demolished about 1910.

WIRTH BUILDING, 13 WEST SUPERIOR STREET. Many early Duluth merchants lived in apartments above their downtown businesses. In 1886, pharmacist Max Wirth asked his brother, respected St. Paul architect George Wirth, to design a new pharmacy with offices and living quarters for Max, his wife Louisa, and their children. George Wirth designed an architectural gem in Richardsonian Romanesque Revival style, with brown and buff colored sandstone, arched windows, and carved stone ornamentation. In addition to the Wirth residence, the second and third floors had offices for professional people. The Wirth Building has been restored, and is listed on the National Register of Historic Places.

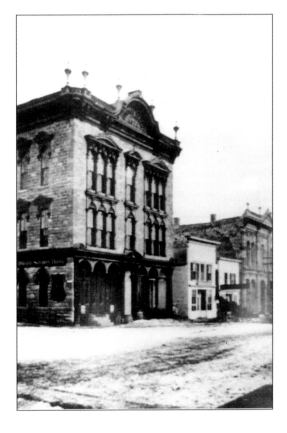

HUNTER BLOCK, 31 WEST SUPERIOR STREET. John C. Hunter came to Duluth in 1870, and immediately ran for mayor. He lost that race, but went on to become an early and important influence in the development of Duluth. He built this brick and stone structure with Victorian motifs to house the Duluth Savings Bank in 1872. In the 20th century the Hunter Block housed Oreck's, a popular clothing store for women and children.

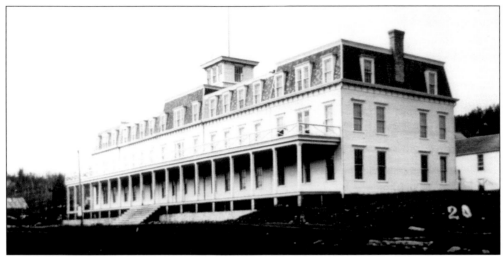

CLARK HOUSE, MID 100 BLOCK OF WEST SUPERIOR STREET. This early hotel opened in the spring of 1870. It was of wood with a mansard roof and a verandah across the front. Jay Cooke supplied the funds through his Duluth representative, George Sargent. During the 1870s, the Clark House was the social center of Duluth as it had facilities to hold dances, dinners, meetings, and parties of all kinds. In August, 1870, the Minnesota legislature held its meetings here. When the Clark House burned in the fall of 1881, it was a huge loss to Duluth. A year later the Metropolitan Block was built on the site.

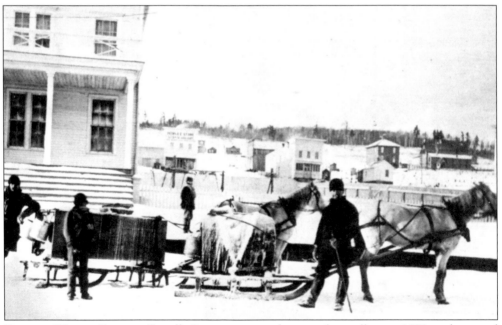

DULUTH WATER SYSTEM. Camille Poirier came to the struggling village in 1870, and engaged in the business of making boots and shoes. He began the early water system, which was made up of large barrels, or "hogs," transported on carts or sleighs. He sold water from these carts and delivered up and down Superior Street. The sleigh is pictured here in front of the Clark House. Poirier also invented and was granted a patent for the Poirier Pack Sack, which is today the "Duluth Pack."

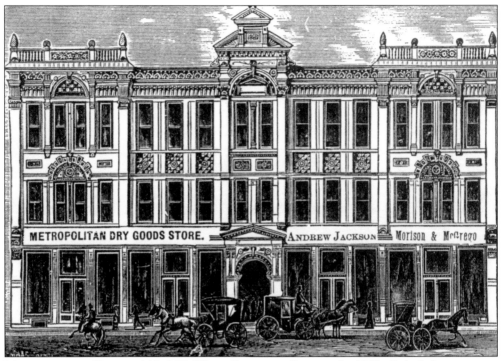

METROPOLITAN BLOCK, 113–119 WEST SUPERIOR STREET. In 1882, Duluth businessmen George Spencer and Melvin Forbes hired St. Paul architect George Wirth to design a large downtown building to house the newly organized Board of Trade, a dry goods store, and offices. The cost was $65,000 for the three-story structure of Buffalo brick and Ohio sandstone with terra cotta trim. By the early 1900s, the Gray Tallant Dry Goods located to the building.

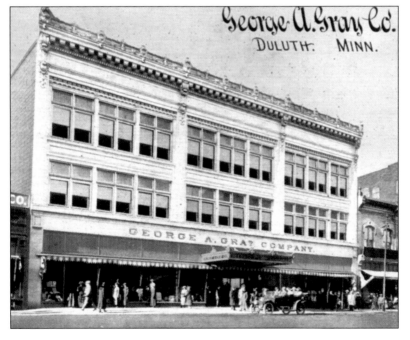

GEORGE GRAY DEPARTMENT STORE. In the 1920s, the Metropolitan block had major remodeling on the facade and became the George Gray Department Store. Some years later it was again remodeled and became Wahl's Department Store, although the 1920s facade was still in place for many more years.

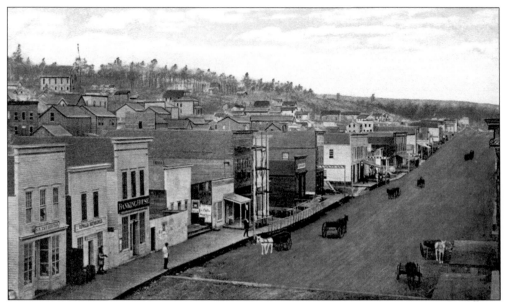

SUPERIOR STREET, 1871. This very early photo of the Duluth business district was taken looking east from about First Avenue West. Early businesses were wooden buildings with false fronts, very likely with residences on the second floors. The third building from the left with the sign "Banking House" was Duluth's first bank, run by George Sargent and George C. Stone for Jay Cooke. The church on the hill was the 1870 Presbyterian Church. The sidewalks in 1871 were four-foot wide boards which bridged the gullies. An early description of Superior Street claimed, "To walk it was hazardous in the daytime and sure death after dark," and to "actually cross [was] an act of recklessness, forfeiting your life insurance."

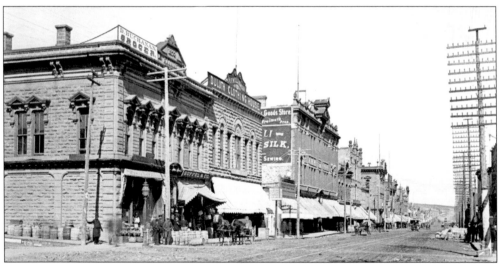

ONE HUNDRED BLOCK OF WEST SUPERIOR STREET. The Victorian buildings in this block are typical of downtown Duluth in 1891. On the corner, the Banning Block was the first sandstone building in Duluth (1872), and next to it the Williamson Block was built in 1884. Sandstone for these buildings was quarried in Fond du Lac. In the middle of the block, the large, brick Metropolitan Block was constructed in 1882. The streetcar lines were running, and deliveries were made by horse-drawn wagons.

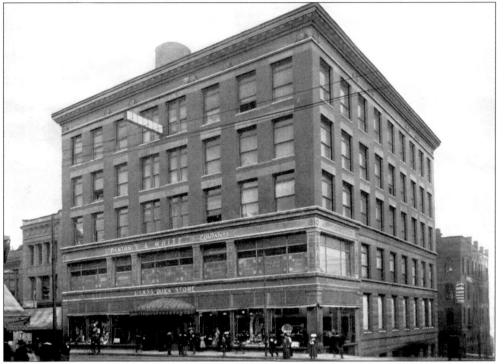

THE GLASS BLOCK, 128 WEST SUPERIOR STREET. This business grew from a small general store begun in 1887 by John Panton and Joseph Watson. By 1893, a larger store was needed, and architect Edwin Radcliffe designed this building which opened with two stories but became five in 1902. The Glass Block name was adopted in 1912, and it was a major department store in downtown Duluth until 1973, when it moved to a mall. Both stores operated until the downtown store was razed in 1981.

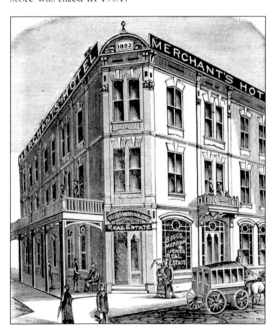

MERCHANTS HOTEL, 202–204 WEST SUPERIOR STREET. The original Merchants Hotel, in the same location, was a wood structure which opened in 1882, but burned in February, 1884. It was immediately rebuilt with a brick veneer on the same footprint and in much the same style. Rates for the hotel in 1884 were $2 a day for a "strictly first class accommodation." Oliver Traphagen designed the second hotel, and he lived here after it was rebuilt, until 1891 when he married and built a house on East Superior Street. Merchants Hotel was demolished in 1907.

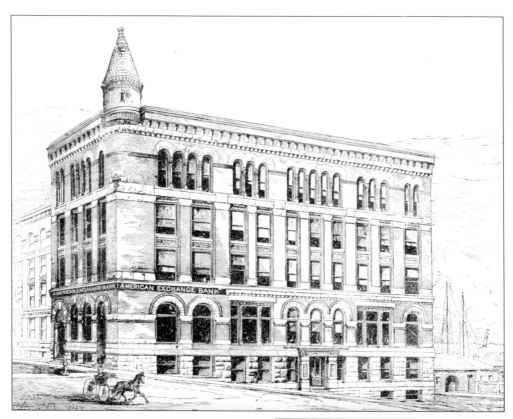

AMERICAN EXCHANGE BANK, 230 WEST SUPERIOR STREET. Duluth businessman George Spencer was the driving force behind construction of this four-story building, which included the banking offices of the American Exchange Bank. Built in 1886, and designed by Oliver Traphagen, it was a standard Romanesque Revival office building, with the exception of the round tower, which appears to have been a last minute addition to the corner roofline. The Exchange Building was demolished in 1958.

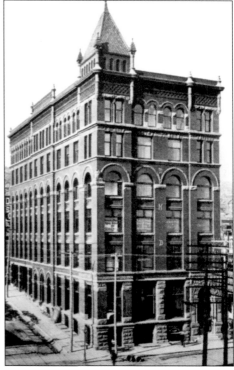

DULUTH NATIONAL BANK, 229–233 WEST SUPERIOR STREET. The Duluth National Bank was built in 1887, one year after and directly across from the American Exchange Bank. It was also designed by Traphagen in the Romanesque style, but is a better example of that style with its taller height and square corner tower, which lend a sense of massiveness. The bank was organized in 1882, and Traphagen's office was here in 1888 through 1889. The building was demolished in 1955.

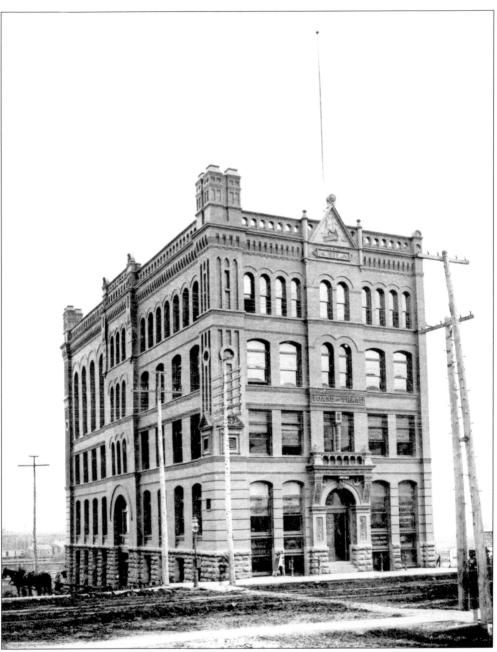

FIRST BOARD OF TRADE BUILDING, 300 WEST SUPERIOR STREET. As early as 1871, a major export from the Port of Duluth was wheat. Later other grains were transported through the port, and the Board of Trade was organized in 1881 with 11 members. In the early years offices were in the Metropolitan Block, but with the rapid development of the grain trade, the commissioners built this brick and stone building in 1885. Designed by George Wirth and Oliver Traphagen, the building was completely destroyed in a February, 1894 fire.

PARADE ON 300 BLOCK OF WEST SUPERIOR STREET. This unidentified band marched on Superior Street c. 1900 while large crowds watched. The building on the left is the Phoenix Block, and the tall office building across the street and down the block is the Torrey Building. The large dark building next to it is the St. Louis Hotel.

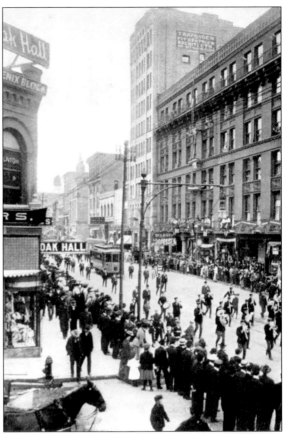

BURROWS BLOCK, 301 WEST SUPERIOR STREET. Matthew Burrows operated a men's clothing store in this building which he had built in 1891 of brick and brownstone. His store, the Great Eastern Clothing Company, was doing so well that occasionally he would place a special announcement in the newspaper, and on that day he and his clerks would throw suits of clothes from the upper windows to the crowds waiting below. In 1957, the building was sheathed with enameled steel in two shades of blue, hiding the original design, and at that time the name was changed to the Beal Building.

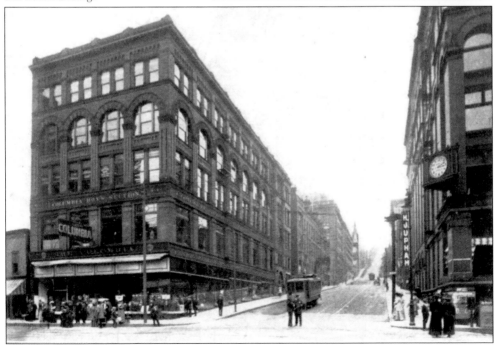

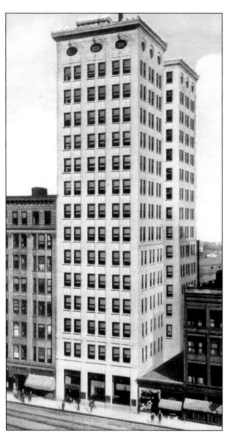

ALWORTH BUILDING, 306 WEST SUPERIOR STREET. Chicago's Daniel Burnham designed this building in 1910, a year after he finished the St. Louis County Courthouse. Marshall H. Alworth commissioned the 16-story concrete and steel skyscraper, which was covered with brick and terra cotta. The decorative elements are limited to the upper stories, especially the cornice. Marshall Alworth was a real estate developer with property in Duluth, and timber and mining lands in northern Minnesota.

FARGUSSON BULIDINGS, 402–408 WEST SUPERIOR STREET. Owen Fargusson, a grain commissioner who was president of the Duluth Board of Trade, owned both of these buildings. The lighter building on the right was built in 1883, and designed by George Wirth. It had a white marble front, classical detailing, and the name Fargusson on the cornice. The building on the left was the creation of Oliver Traphagen and built in 1886. It was of red brick and the roof was lined with turrets. Both buildings came to a disastrous end in December, 1892, when fire gutted them. The 1883 section was a complete ruin, and the 1886 section was at first thought able to be saved but later was determined to be too badly damaged. Both were torn down in February, 1893.

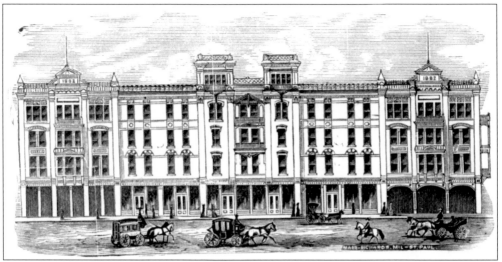

St. Louis Hotel, 318–324 West Superior Street. Two different hotels called the "St. Louis" stood on this site. The first was built in 1882 to replace the Clark House which had burned in 1881. The 1882 St. Louis was four stories of red and white brick. A large addition in 1887 more than doubled the space. Fire destroyed the original hotel and the addition in January, 1893, with the loss of three lives.

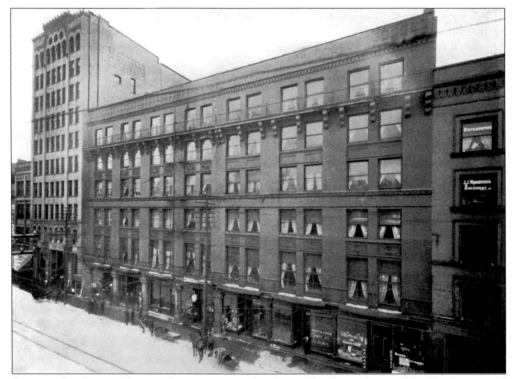

Second St. Louis Hotel. A new six-story St. Louis Hotel was designed by Traphagen and Fitzpatrick, and construction started soon after the fire. For many years it was one of Duluth's most popular hotels until it was demolished in 1932.

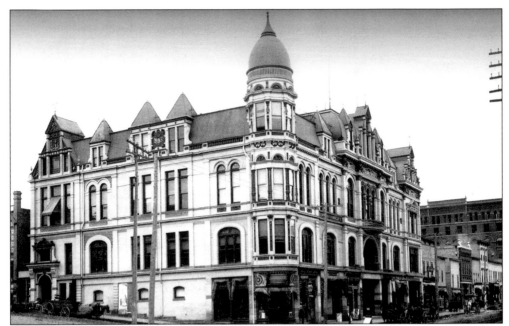

GRAND OPERA HOUSE, NORTHEAST CORNER FOURTH AVENUE WEST AND SUPERIOR STREET.
Duluth newspapers called it the finest opera house west of Chicago when it opened in September, 1883. Duluth pioneers Roger Munger and Clinton Markell hired St. Paul architect George Wirth to design an elegant theater for them. In addition to the theater, there were retail stores, offices, and rented rooms. Four stories with a corner tower, brick walls, and terra cotta trim, it seated 1,000. Only six years later on a cold January night it was completely destroyed by fire and all the walls collapsing by morning. Men rooming on the fourth floor had to be rescued by ladders. The only life lost was the owner of the bookstore next door who was trying to save the contents of his building and was killed when the east wall of the opera house fell.

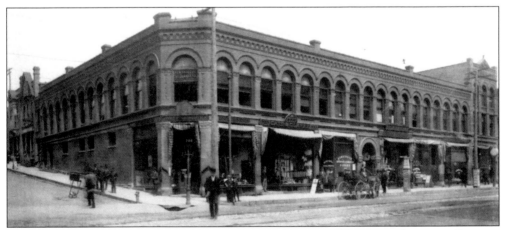

PHOENIX BUILDING, NORTHEAST CORNER FOURTH AVENUE WEST AND SUPERIOR STREET.
Like the mythical bird, this building rose from the ashes of the Grand Opera House in 1890. In place of the elaborate opera house, this office building, designed by Oliver Traphagen, was two stories of red brick, with rows of arched windows on both sides of the second story. For many years it was one of Duluth's most prestigious office buildings. It too succumbed to fire in December, 1994, and has since been rebuilt from the ground up, but in a different style.

SPALDING HOTEL, SOUTHEAST CORNER FIFTH AVENUE WEST AND SUPERIOR STREET. Brothers W.W. and I.C. Spalding came to Duluth in 1869, and ran a general store on this corner where, in June of 1889, the 7-story, 200-room Spalding Hotel opened. The elegant establishment had the Palm Dining Room, with live palms and also an outdoor pavilion on the roof which afforded a spectacular view of the harbor. The hotel's exterior was brownstone, brick, and terra cotta. Designed by Chicago architect James Egan, the Spalding was for many years considered Duluth's finest hotel. It closed July 1, 1963, and was demolished in November of that year.

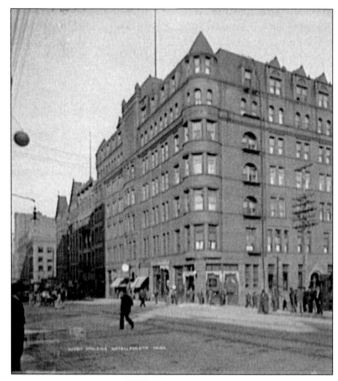

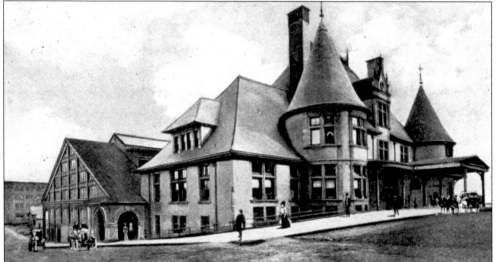

DULUTH UNION DEPOT, FIFTH AVENUE WEST AND MICHIGAN STREET. In the 1880s, the Northern Pacific and the St. Paul & Duluth Railways were bringing immigrants and supplies to Duluth and needed a large depot for traffic. In 1892, the Union Depot opened. Nationally prominent architects Peabody & Stearns of Boston produced the yellow brick Chateauesque design, with steep roofs and heavy round towers. In the 1890s, 60 trains a day stopped in Duluth carrying European immigrants to the Iron Range and taking Duluthians south and east on business and vacations. As railway traffic declined in the mid-20th century, the depot suffered and finally closed in 1969. It was remodeled in the early 1970s as the St. Louis County Heritage and Arts Center with museums, galleries, and performance spaces.

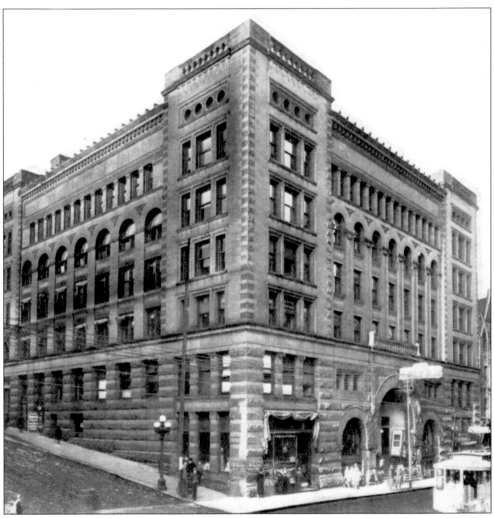

LYCEUM THEATER, 423–431 WEST SUPERIOR STREET. The Lyceum Theater was called "the finest place of amusement in the Northwest." Traphagen and Fizpatrick designed the brick and brownstone structure with four massive corner towers and arched windows. The triple arched entrance had bronze doors and was surrounded by carved brownstone with theatrical masques, lions, and floral motifs. A.M. Miller, a Duluth lumberman, financed the Lyceum which opened in 1892, and operas, plays, and vaudeville performed here until 1921, when it became a movie house. It was demolished in 1966, but the theatrical masques were saved to grace the entrance to the Depot Theatre, and the stone lions stand guard at the Duluth Zoo.

LYCEUM THEATER ENTRANCE. George Thrana, Duluth's master stone carver, came to Duluth in 1889 from Norway where he had been trained as a stone sculptor. For 40 years he carved in sandstone, granite, marble, and limestone for Duluth buildings. His finest work can be seen here on the Lyceum Theater. Other buildings which exhibit Thrana's outstanding sculpting are Central High School, Glensheen, Board of Trade, County Courthouse, County Jail, and Denfeld High School.

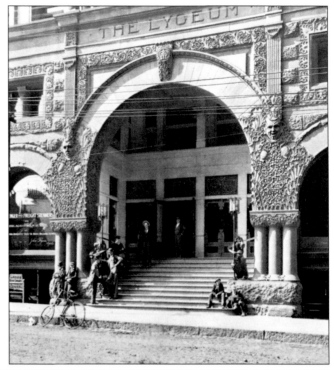

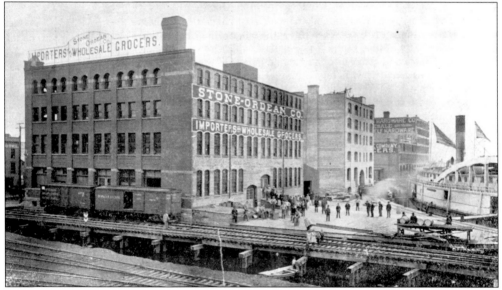

WHOLESALE DISTRICT, WEST FIFTH AVENUE SOUTH. Wholesale business began in Duluth in 1881 and quickly grew, as this 1895 photo indicates. On the left is the Stone-Ordean Company, Duluth's first wholesaler. It supplied groceries to firms throughout the region. Next to Stone-Ordean is Leithhead Drug, and beyond that is the Wells-Stone Warehouse, another grocery wholesaler. The last building in this grouping is the Marshall-Wells Hardware Warehouse. The district was conveniently located on Slip One with railway tracks nearby. The buildings were all designed by Oliver Traphagen and built between 1888 and 1893, and all were demolished in the 1960s.

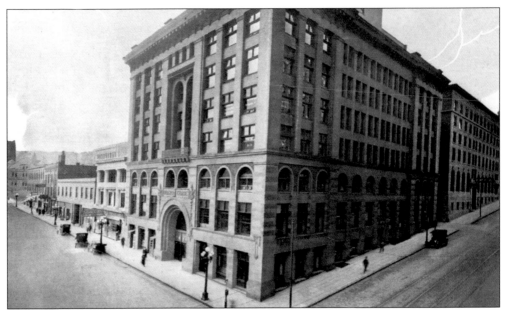

SECOND BOARD OF TRADE BUILDING, 301 WEST FIRST STREET. In 1893, the Board of Commissioners planned to build a larger facility than the existing one on Superior Street. Traphagen and Fitzpatrick drew plans for what would be their last building in Duluth, but the financial crash of 1893 delayed construction until the old Board of Trade Building burned in February of 1894, and new building became a necessity. It is a fine example of the Romanesque style in brick and stone, and features a two-story carved and arched entrance. A rear addition by Chicago architect Daniel Burnham was added in 1905, and in 1948 the decorative cornice was damaged and removed due to a fire which destroyed a furniture store across the street.

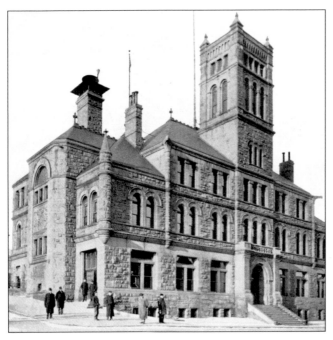

UNITED STATES GOVERNMENT BUILDING, 431 WEST FIRST STREET. This striking Romanesque Revival building of stone was built in 1894. A heavy, massive structure with arched windows, Bedford stone trim, and a five-story square tower, it was designed by the team of Traphagen and Fitzpatrick, Duluth architects. Although it may have had other federal government offices, it was primarily known as the post office building. It served the Duluth community until the present post office/government building was built in the Civic Center. This building was demolished in 1934.

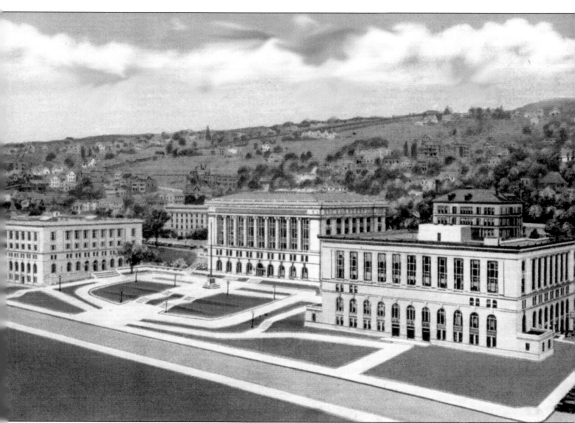

CIVIC CENTER HISTORIC DISTRICT, FIFTH AVENUE WEST AND FIRST STREET. The Duluth Civic Center Mall was designed by noted American architect Daniel Burnham and included courthouse, city hall, federal building, and monument on the mall. These are classic examples of the "City Beautiful Movement" of the early 1900s. Burnham designed the County Courthouse, which opened in 1909, and is a Classical/Renaissance Revival style with columns, lions' heads, and arched openings and occupies the focal point of the district. The St. Louis County Jail was built on Second Street in 1923. It was designed by the Duluth firm of Abraham Holstead and William J. Sullivan, and is also in the Classical style of gray granite with lions' head motifs. Local architectural firm Shefchik and Olsen designed the Duluth City Hall in keeping with Burnham's plan. The Classical style building with Doric columns and lions' heads was built in 1928. The Federal Building/United States Courthouse and Custom House was built in 1929, and designed by federal architects. It faces and balances City Hall across the mall. The Soldiers and Sailors Monument was installed in the center of the mall in 1919. It commemorates Duluthians who died in overseas wars, and was designed by prominent Minnesota architect Cass Gilbert. The fountain was added in the 1960s. The Duluth Civic Center Historic District is listed on the National Register of Historic Places.

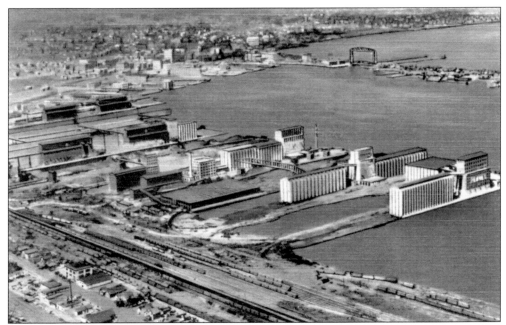

GRAIN ELEVATORS, RICE'S POINT. The first grain shipment out of Duluth was in May of 1871. During the 1880s and 90s, many of these elevators and mills were built along Rice's Point, with nearby railway tracks bringing wheat from western Minnesota and the Dakotas to be milled and shipped out of the Great Lakes. By 1895, Duluth was ranked second in the country in production of flour, with a capacity of 19,000 barrels a day in its 10 mills. Many of the grain elevators have been lost to fire or demolition, but a few still operate.

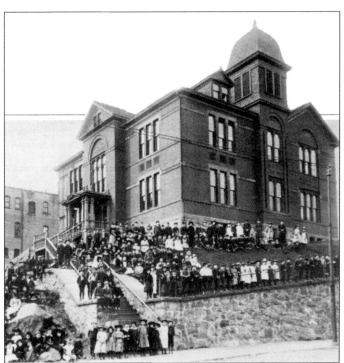

ADAMS SCHOOL, 1721 WEST SUPERIOR STREET. The Adams School was built in 1885 to serve families in the near West End neighborhood. Architects were McMillen and Stebbins. The entire school student body and staff are pictured here. Adams School closed in 1951, and was demolished about 1960.

Four

WESTERN ENVIRONS

The West End, now called Lincoln Park, dates back to the 1860s when Rice's Point on the waterfront became home to sawmills, hotels, boarding houses, and headquarters for crews building the first railway to Duluth. An active commercial district developed along West Superior Street around 20th Avenue West. Farther west, the Village of West Duluth was incorporated in 1888 to serve as the industrial area for Duluth. Its commercial district was centered on Central Avenue, and the industrial workers lived nearby.

Riverside and Morgan Park were company towns for employees of the shipyards and the steel plant. Gary and New Duluth were residential towns for workers at the many other industrial plants. All these villages were absorbed by the City of Duluth by 1900, even Fond du Lac at the far west end, where the very first activities by Europeans and Yankees were centered in the early 1800s.

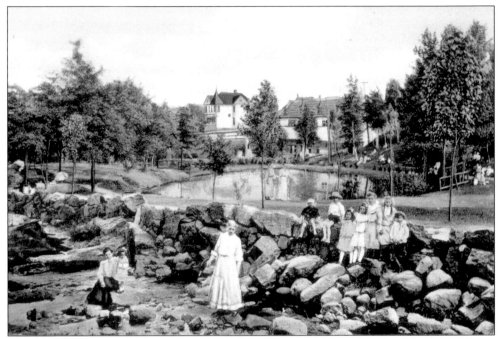

LINCOLN PARK, WEST THIRD STREET AND 25TH AVENUE WEST. The land for this park was acquired between 1889 and 1928. Miller Creek runs through the wonderfully wooded park. Workers on federal programs built a stone pavilion in 1934.

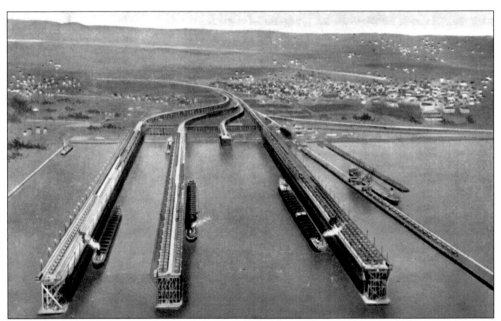

ORE DOCKS, 35TH AVENUE WEST ON THE ST. LOUIS RIVER. The Duluth, Missabe, and Northern Railway built the first ore dock here in 1893 to load iron ore from Minnesota's iron ranges for shipment to steel plants in the east. The first five docks were built in the 1890s of wood, which was gradually replaced by steel and concrete. West End (Lincoln Park) is on the right, and West Duluth on the left, separated by the oar docks.

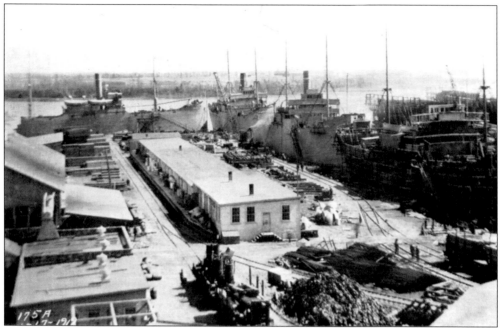

MᴄDᴏᴜGᴀʟʟ-Dᴜʟᴜᴛʜ Sʜɪᴘʏᴀʀᴅs, Sᴘʀɪɴɢ Sᴛʀᴇᴇᴛ ɪɴ Rɪᴠᴇʀsɪᴅᴇ. Alexander McDougall was a seaman, captain, shipbuilder, and inventor, who in 1917, organized and served as president of the McDougall-Duluth Shipyards on the St. Louis River. The company was organized to build ships for the government during World War I. The shipyard shut down in the 1920s, but opened again in 1942 to build ships for World War II. The shipyard closed permanently in the 1950s.

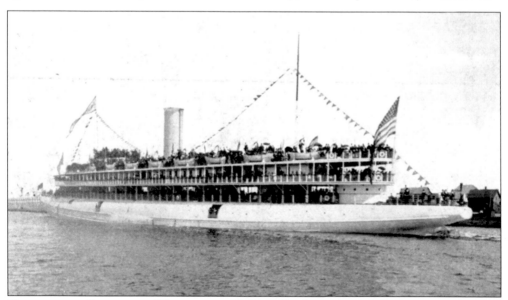

Cʜʀɪsᴛᴏᴘʜᴇʀ Cᴏʟᴜᴍʙᴜs—Wʜᴀʟᴇʙᴀᴄᴋ. McDougall is better known for the invention of the "whaleback," a flat-bottomed lake freighter with rounded sides and deck and a snout-nosed bow, which gave them the nickname "pigboats." The first whaleback was launched in 1888, and the most famous was the *Christopher Columbus*, a passenger whaleback built for service at the 1893 World's Columbian Exposition in Chicago. It was broken up in 1936.

WORK PEOPLES COLLEGE, 402 SOUTH 88TH AVENUE WEST. This building housed the "Finn College," so called because many of the students and teachers were Finnish. It opened in 1903, and at its peak in 1914 had 150 students. The curriculum taught Marxism in addition to general education courses. The Finn College closed in 1940, and the building was converted to apartments.

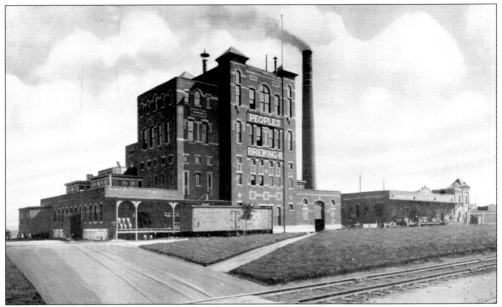

PEOPLE'S BREWING COMPANY, 42ND AND TRAVERSE. In 1907, saloonkeepers in West Duluth organized their own brewery. They built this building and operated the brewery for 50 years. All of the larger buildings have been demolished, and only the building on the far right in the photo is still standing.

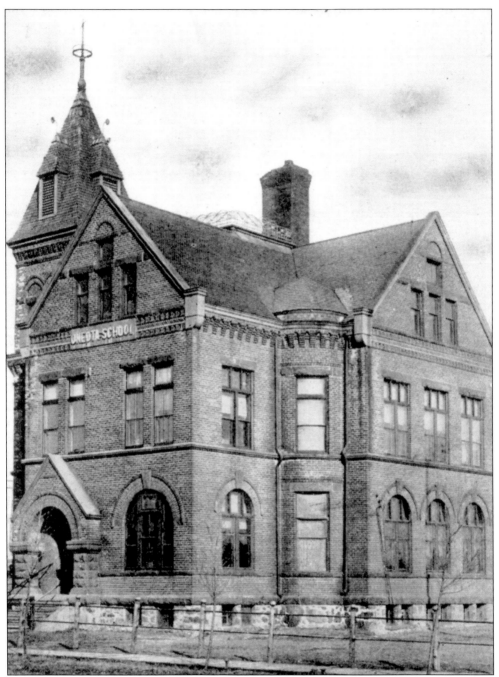

ONEOTA SCHOOL, 4420 WEST FIRST STREET. Oneota was one of the earliest settlements that comprise the present Duluth. The Wheeler and Merritt families were among the earliest settlers of Oneota in the 1850s. An early Duluth schoolhouse was built here in 1856, and was replaced in 1888 with this brick Romanesque style design by Oliver Traphagen. It also served as the Oneota Village Council Chambers before the village became part of West Duluth. The school closed in 1947, was used for storage, and was finally demolished in 1973 for the construction of an industrial park.

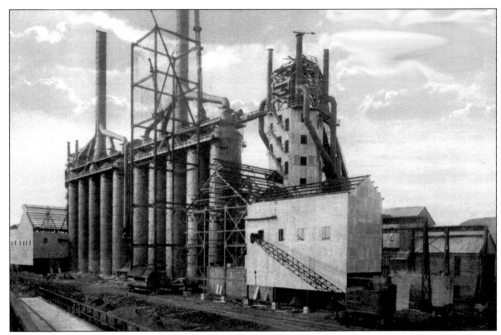

UNITED STATES STEEL PLANT, MORGAN PARK. The announcement to build a steel plant in Duluth was made in 1907, but it was late in 1915 before the first steel was produced. Pictured here are the blast furnaces of the huge plant, which produced steel ingots and wire. At one time the plant had a work force of over 5,000 employees. Long distances from manufacturing plants, and growing concerns about pollution and the economy caused the plant to close during the 1970s. The structures on the site were demolished by the 1990s.

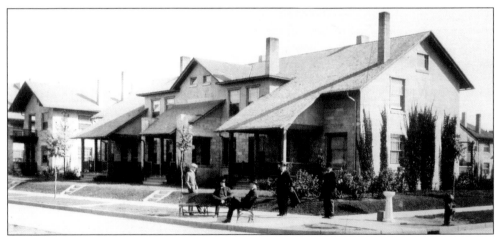

MORGAN PARK. This was a company town created by the United States Steel Corporation to house their employees. The town was named for J.P. Morgan, the financier who helped to organize U.S. Steel, and construction of the concrete block homes began in 1913. Morrell and Nichols of Minneapolis were the landscape architects and town planners, and Dean and Dean of Chicago were the architects. U.S. Steel owned the houses, which were rented exclusively to employees. Schools, churches, stores, a hospital, bank, and a community center were maintained for the residents. In 1942, the houses were sold to the employee residents and others. The mill closed in the 1970s, and Morgan Park became a Duluth suburb with residents working elsewhere.

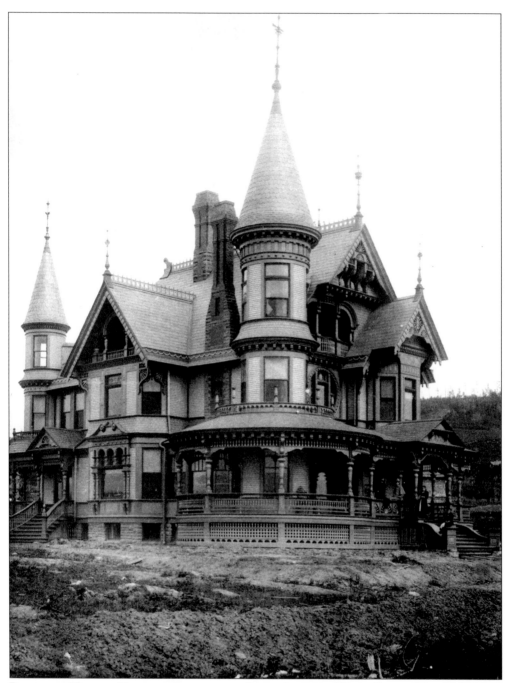

PRESCOTT HOUSE, CENTRAL PLACE, AND 54TH AVENUE WEST. Dewitt Clinton Prescott founded the Marinette Iron Works in Marinette, Wisconsin, but in 1890 he moved the firm, which manufactured steam engines and saw mill machinery, to West Duluth. Prescott built the family mansion in the Queen Anne style with towers, gables, finials, tall chimneys, spindle work, and a curved verandah. By 1899, the Prescotts had moved to Chicago, and over the years the house was occupied by other families and was a hospital for a time. It was eventually abandoned and was known as a haunted house until it was demolished in 1948.

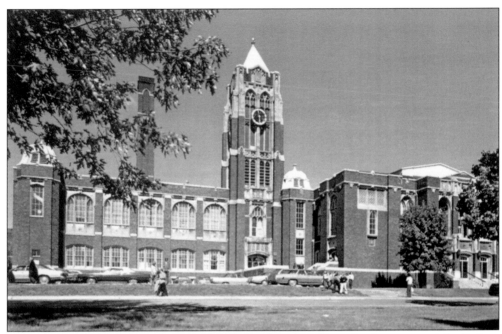

DENFELD HIGH SCHOOL, 4405 WEST FOURTH STREET. The school was named for Robert Denfeld who served as superintendent of Duluth schools from 1885 to 1916. This was during a period of rapid growth in Duluth's population and building of schools. Duluth architects Abraham Holstead and W.J. Sullivan designed the H-shaped, Collegiate style building, which has a square clock tower and carved medieval symbols. The building opened in 1926.

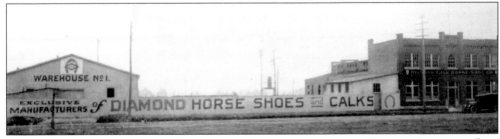

DIAMOND CALK HORSESHOE COMPANY, 47TH AVENUE AND GRAND AVENUE. Otto Swanstrom was an experienced blacksmith who searched for a better way to attach horseshoes. Projections on horseshoes to prevent them from slipping off were called calks, and although various screw-calks had been used, none were completely satisfactory. Swanstrom invented a drive-calk which could be hammered on the hooves of horses or mules. He organized the Diamond Calk Horseshoe Company, and began manufacturing in 1901. The business was hugely successful, and later added tools to the manufacturing line. Diamond Tool closed in 1994, and the building was razed in 1996.

WEST DULUTH VILLAGE HALL, 531 CENTRAL AVENUE. West Duluth became a village in 1888, and this building opened the following year as headquarters for the fire and police departments and all village offices. It was designed by Oliver Traphagen as a brick, Romanesque style structure, with arched windows and doors, and a square roof tower. After it closed as a village hall, the tower was removed and an addition was built on the front.

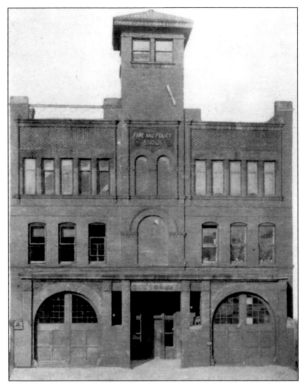

LEONIDAS MERRITT. Leonidas Merritt was the first president of the West Duluth Board of Trustees. He was a son of Lewis and Hepzibah Merritt, early settlers of Oneota. He later was one of the Merritt brothers who explored and developed the Mesabi Iron Range.

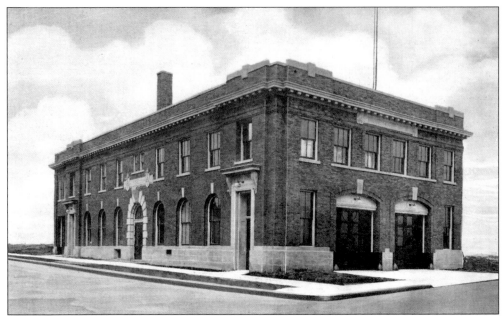

WEST DULUTH MUNICIPAL BUILDING, 601 CENTRAL AVENUE. When West Duluth became part of Duluth, and the village hall was abandoned, it seemed necessary for West Duluth to have a building for its services. This was constructed in 1916 to serve as a branch of Duluth city government, with fire and police departments and a municipal court. Frederick German designed it in the Classical Revival style. When city offices moved out in the 1990s, it became an apartment building.

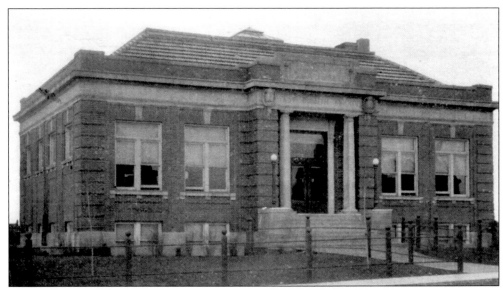

WEST DULUTH BRANCH LIBRARY, 701 CENTRAL AVENUE NORTH. The library opened in 1912 as a branch of the Duluth Public Library. It was designed by William J. Sullivan, and built in the Classical style with brick and terra cotta trim. It closed and was demolished in the early 1990s.

BERT ONSGARD—FOUNDER OF DULUTH ZOO. In 1923, Bert Onsgard, a Duluth printer, rescued a deer and built a cage for it in Fairmount Park. That was the beginning of Duluth's Fairmount Zoo, eventually becoming the Lake Superior Zoo. Onsgard campaigned for a zoo, managing it from 1923 to 1937, and often paid for the animals' food himself when times were hard.

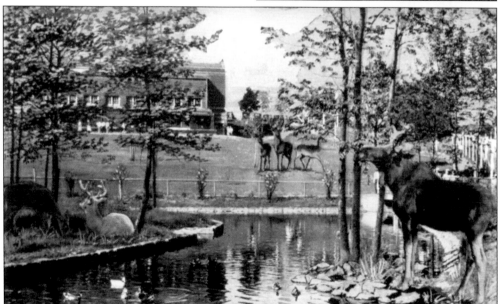

LAKE SUPERIOR ZOO, 72ND AVENUE WEST AND GRAND. The zoo's most famous resident was "Mr. Magoo," a mongoose given to the zoo in 1962 by a seaman on a foreign vessel visiting the harbor. The mongoose was ordered destroyed by the United States Fish and Wildlife Service, but received a reprieve from Secretary of Interior Stuart Udall. Mr. Magoo entertained zoo visitors until 1968, when he died. He was then stuffed and is still on display at the zoo.

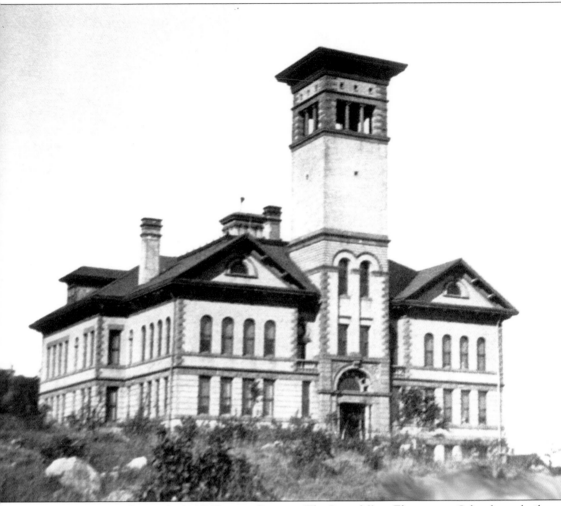

LONGFELLOW SCHOOL, 6015 ELINOR STREET. The Longfellow Elementary School was built in 1891, having been designed by Palmer, Hall, and Hunt, the architects of the Central High School. Built on a hill, its five-story square bell tower could be seen from long distances. Longfellow closed in 1956, and was demolished in 1959.

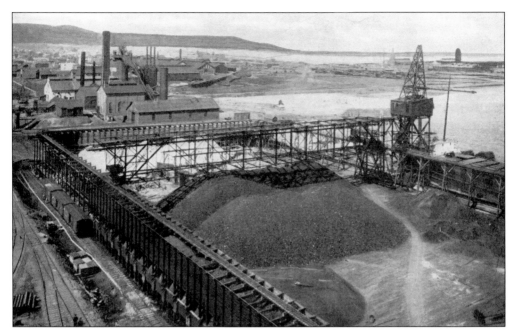

ZENITH FURNACE COMPANY, 59TH AVENUE WEST AND ST. LOUIS BAY. The Zenith Furnace Company was organized in 1902, a successor to an earlier blast furnace. It manufactured pig iron and by-products of coal gas, ammonia, and coal tar. In 1931, it was acquired by Interlake Iron Corporation, and was an important source of steel during World War II for use in government defense equipment. It closed in 1962.

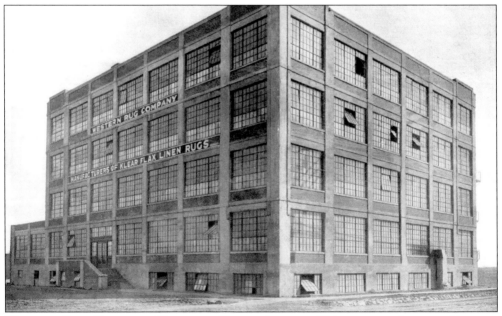

WESTERN RUG COMPANY, 63RD AND GRAND AVENUE. This company began making rugs from flax in 1909. It produced fine linen "Klearflax" rugs and carpets for both domestic and international markets. The name was later changed to Klearflax Linen Looms, Inc. The company was sold in 1953, and closed soon after. The building was imploded in 1987.

59

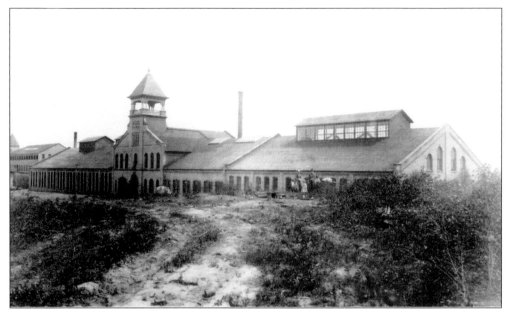

MARINETTE IRON WORKS, 50TH AVENUE WEST AND ROOSEVELT. The Marinette Iron Works manufactured steam engines and sawmill machinery. It was started in Marinette, Wisconsin, and the owner, Dewitt Clinton Prescott, moved his family and the entire company to Duluth in 1890. The iron works closed in 1898, and became the Union Match Company which produced wooden matches made from white pine. The buildings have since been demolished.

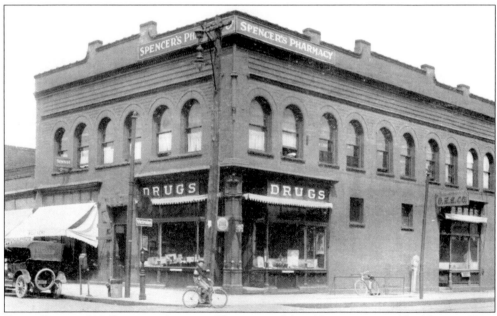

SILVEY BLOCK, 402 CENTRAL AVENUE. This is one of the oldest commercial buildings in West Duluth. A Romanesque Revival with arched windows and stone trim, it was built as an office building in 1893 by William Silvey, a wealthy real estate businessman. He and his wife Alice, a daughter of Roger Munger, were passengers on the ill-fated Titanic in April, 1912. His wife was rescued, but Silvey died when the ship went down.

TRAPHAGEN BLOCK, 301–303 CENTRAL AVENUE. Oliver G. Traphagen designed and built this two-story brick commercial building in 1888, but he sold it when he left Duluth in 1896. Dr. David Graham had his practice here, and opened the Graham Hospital on the second floor about 1905. When Graham died in 1933, the second floor became the West Duluth Hotel. For many years the rear of the Traphagen Block was the West Duluth Post Office. The entrance to the post office was the door on the left side of the building near the back.

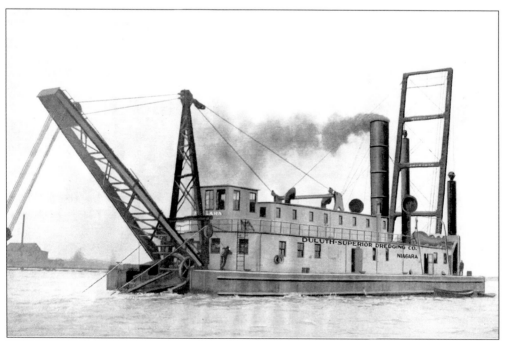

DULUTH-SUPERIOR DREDGE COMPANY, FOOT OF 45TH AVENUE WEST. Duluth-Superior Dredge Company, which was organized in the early 1900s, specialized in dredging and building docks and wharves in all parts of the country. By 1909, it was located at 45th Avenue West on the St. Louis River, next to the Northern Pacific Railway crossing. Operations remained there until 1956, when the dredge company was sold and closed.

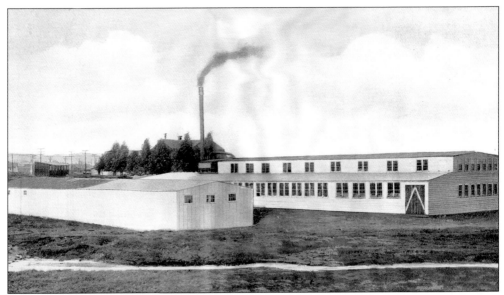

E.G. Wallinder's Sash and Door Company, 59th Avenue West and Nicollet. Erich G. Wallinder began business in 1890 in the newly organized Village of West Duluth, drawing lumber resources from the vast tracts available in northern Minnesota. Wallinder created a woodworking business, which produced doors, windows, blinds, and all kinds of millwork for buildings in the Midwest. Wallinder's was a large and successful business, but closed when fire swept through the buildings in December of 1944.

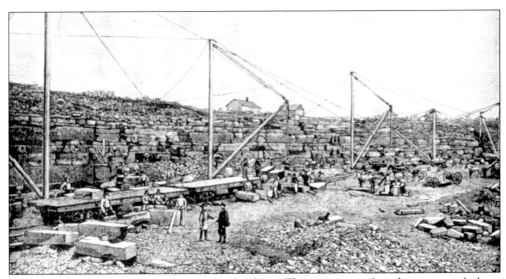

Duluth Brownstone Company, Fond du Lac. The quarrying of sandstone started about 1870 near the St. Louis River in Fond du Lac, but the industry's real growth began in 1880. When Duluth rebounded from the depression of the 1870s, there was demand for building materials more resistant to fire than the early wood structures which lined downtown streets. Duluth Brownstone Company purchased an already established quarry in 1886, and in this sketch can be seen the sandstone formations and equipment used to cut and lift blocks of stone. Sandstone from Fond du Lac was used extensively in Duluth buildings, but was also shipped to the Twin Cities and to other states. The use of brownstone continued until 1910; no quarrying is done today in Fond du Lac.

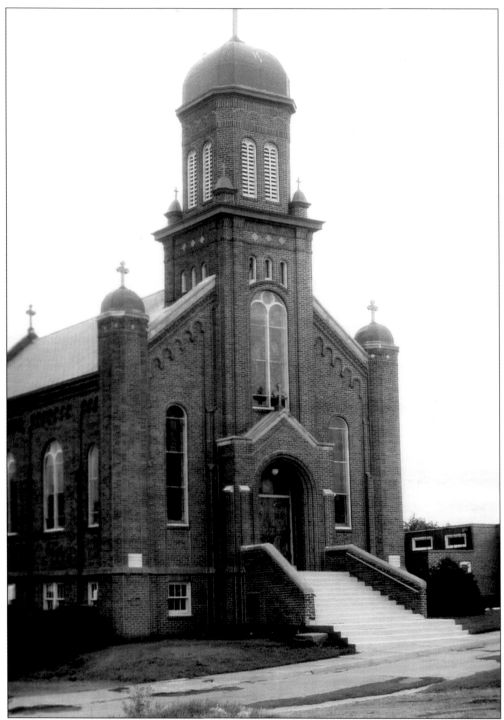

St. George Serbian Orthodox Church, 1216 104th Avenue West. Serbian immigrants who came to Duluth in the early 1900s and worked on the Thomson Dam and U.S. Steel founded this church. It was completed in 1924, and has a dome and 12 gold crosses on the exterior, and many icons in the interior.

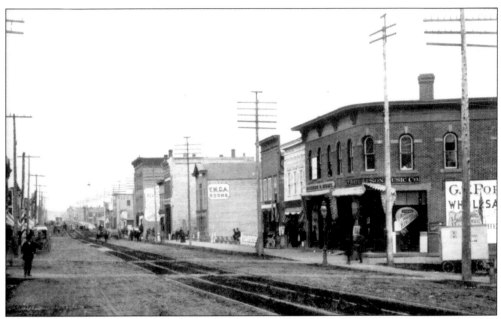

SUPERIOR STREET, EAST FROM LAKE AVENUE. The lower side of Superior Street about 1886 has the Porter Block, which contained a music store on the corner. Down the block is the frame building housing Duluth's YMCA which was organized in 1882. The next tall building is the J.J. Costello Block, which still stands. On the far corner is the Hayes Block, which was one of the first brick structures in Duluth, and was built by Rutherford B. Hayes, president of the United States from 1877–1881.

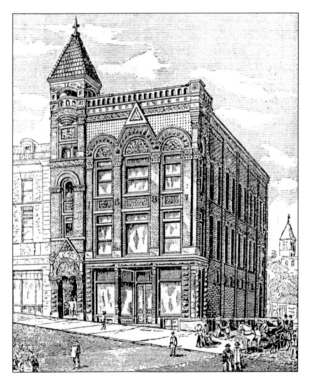

ODD FELLOWS HALL, 20 NORTH LAKE AVENUE. Oliver Traphagen designed this brick and stone fraternal lodge in 1888. It was four stories with a square corner tower. At one time the lodge had a membership of over 1000. By the 1930s the building housed a theater and later a furniture store. When the Odd Fellows Hall was demolished in 1975 brownstone carvings that had decorated the building were saved and used on a house.

Five

EAST DOWNTOWN

East downtown also had early buildings with businesses and second story homes near Lake Avenue. Activity here was mainly retail with fraternal organizations and theaters built in the 1870s and 1880s. Early government buildings—post office, city hall, and police headquarters— also were located in east downtown from 1860 to the 1900s or even later. More of Duluth's early structures survived here than west of Lake Avenue, so the name of "Old Downtown" has been applied to the area from Lake Avenue to East Fourth Street on Superior.

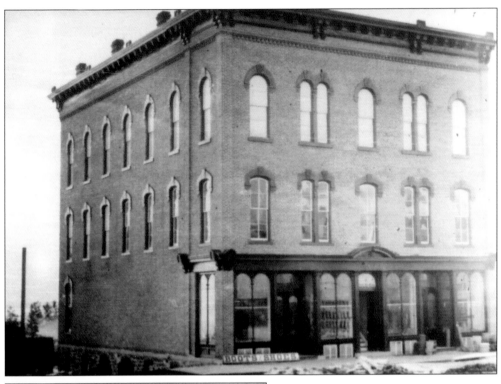

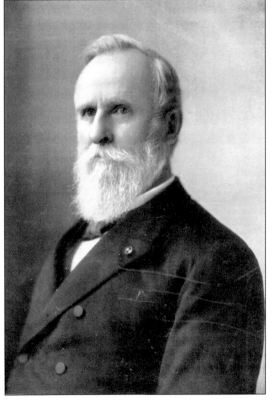

HAYES BLOCK, 30–38 EAST SUPERIOR STREET. The original building was financed and owned by Rutherford B. Hayes in 1870, while he was governor of Ohio. It was the second and largest brick structure in Duluth. In its early years it served as city offices, post office, and Masonic Lodge. It was partially demolished and remodeled in 1906.

RUTHERFORD B. HAYES. Hayes may have become interested in Duluth through friendships with several Ohio residents who came here from that state in the 1860s. Hayes served as president of the United States from 1877 to 1881 and visited Duluth several times after his term expired.

PASTORET STENSON BLOCK, 29–33 EAST SUPERIOR STREET. Michael Pastoret and Olaf Stenson commissioned Oliver Traphagen to design this six-story brick office building in 1888. In March of 1930, an explosion rocked the building and the ensuing fire killed four people who lived in apartments on the upper floors. The explosion occurred in the B&Y cap company on the second floor, where it was rumored that a still was in operation. This was during prohibition, and Duluth had a large underground liquor industry. The top three heavily damaged floors had to be removed. The bottom three floors were repaired and were used until their demolition in 1999. A close replica of the Pastoret-Stenson's first three floors was built in its place.

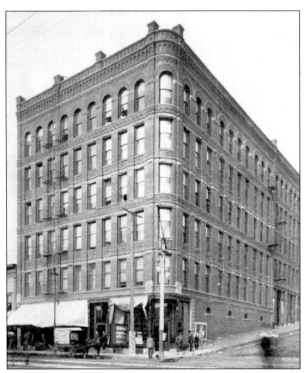

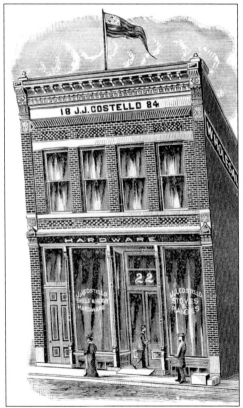

COSTELLO BLOCK, 22–24 EAST SUPERIOR STREET. The two sections of the Costello Block are identical, but were built at two different times. Number 24 was originally numbered 22, and was designed by George Wirth and built in 1884. The present 22 was built in 1891, and is credited to architect Oliver Traphagen. John Costello, and later his cousin R.A. Costello, conducted a hardware store here for many years.

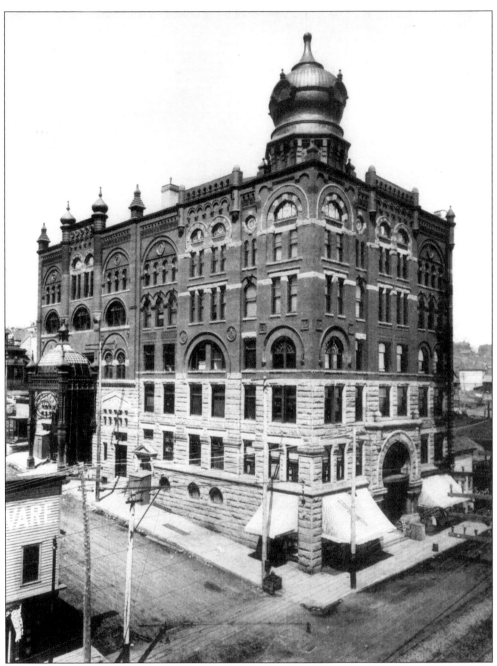

MASONIC TEMPLE OPERA BLOCK, 201–205 EAST SUPERIOR STREET. After fire destroyed the Grand Opera House, this was built as a theater, Masonic Lodge, and office building. The Richardsonian Romanesque Revival brownstone building was designed by Duluth architects Charles McMillen and E.S. Stebbins in 1889. Originally six stories with a bulbous Moorish tower and turrets on the roof, the top three stories were removed in the early 1940s when G.G. Hartley realized that the building which he owned blocked the view of the new 3000 light tower on his remodeled Norshor Theater. Ornately carved faces and scrollwork in brownstone can be found on the first story. Duluth's first public library opened on the second floor in 1889.

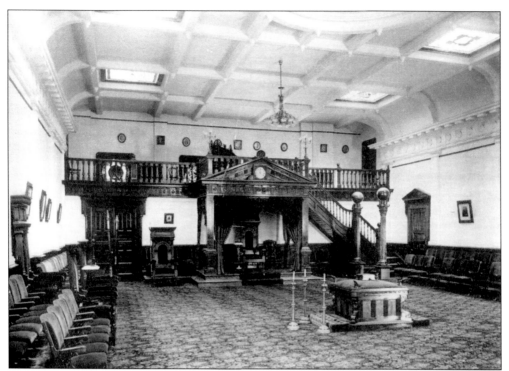

INTERIOR OF MASONIC TEMPLE OPERA BLOCK. The upper floors of the Temple Opera Block were rooms for the Masonic Lodges and performances of their rites and ceremonies. This was the room for the Blue Lodge with the fixtures and furnishings for their rituals.

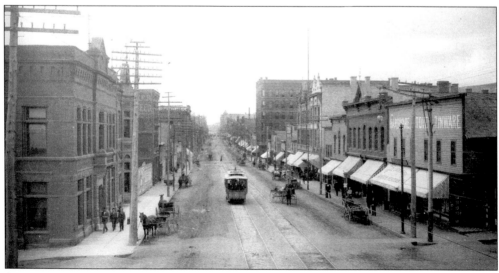

SUPERIOR STREET LOOKING WEST FROM SECOND AVENUE EAST. Streetcars, horse drawn wagons, and pedestrians travel Duluth's main street in 1891. To the left is the new City Hall, and next to it the Police Headquarters built in 1889 and 1891 respectively. Across the street are Fieberger's Hardware on the corner and the Burg-Kugler Block next door. The tallest building in the next block is the Pastoret-Stenson Block. Notice the awnings to protect goods in display windows from the sun.

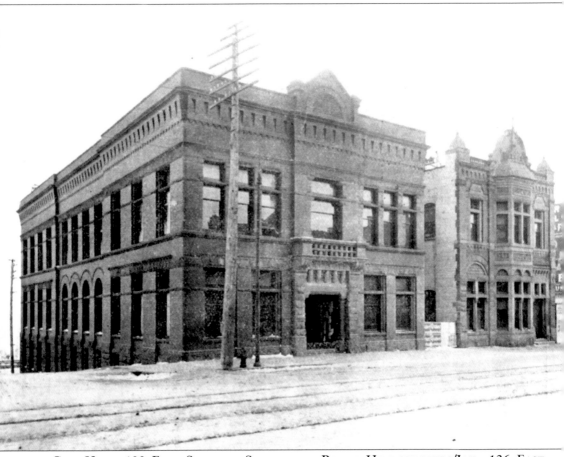

City Hall, 132 East Superior Street and Police Headquarters/Jail, 126 East Superior Street. After Jay Cooke's bankruptcy in 1873, and the ensuing recession, Duluth had been reduced to village status and lost half its population. During the 1880s, Duluth recovered economically and the city administration decided to build a new city hall. Oliver Traphagen was hired to design the brick, stone, and terra cotta building which opened on January 30, 1889. City hall was immediately filled, and city fathers recognized the police and jail required a separate structure. The Police Headquarters and Jail, also designed by Oliver Traphagen in a more picturesque style with Flemish gable and stone carvings, was completed next door to City Hall in 1891. It was restored to its original design in 1968. By the 1920s, both buildings were crowded, and the present City Hall with Police Department opened in 1929.

(*opposite*) **Hotel Duluth, 219–231 East Superior Street.** Duluth's largest hotel was built as one of the Schroeder chain of hotels and opened in 1925. The 14-story, Classical Revival facade is decorated with rosettes, swags, Corinthian columns, bronze lamps, and terra cotta canopies. Over the years the hotel was host to many celebrities, including Henry Fonda, Charles Boyer, Liberace, Pearl Bailey, and President John F. Kennedy, just two months before his death. An often-repeated story is that of the 350-pound hungry bear who got into the coffee shop early one Sunday morning

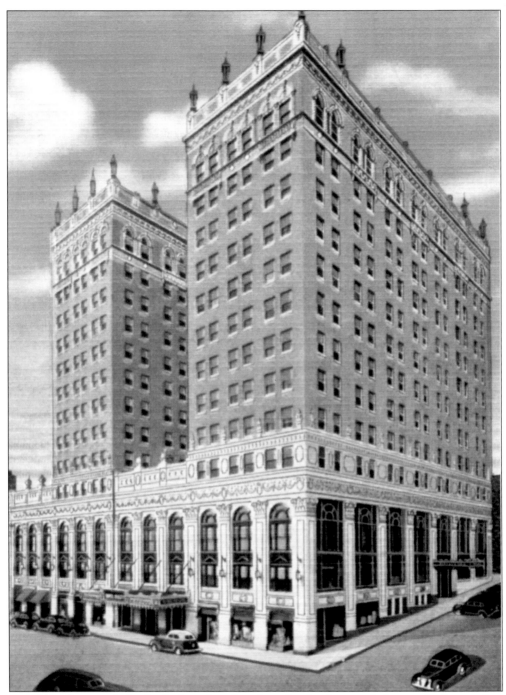

in 1929 in his search for food. Crowds gathered, and a drunk started chasing the bear with a hammer. The excitement grew until the police were called, and they at first attempted to lasso the bear. That was a foolish thing to do as the bear broke free and went for the rear of the coffee shop where people were gathered and the police were forced to kill the trapped bear. When prohibition ended in 1932, the coffee shop became a cocktail lounge appropriately named the "Black Bear Lounge" where the stuffed bear was exhibited for many years.

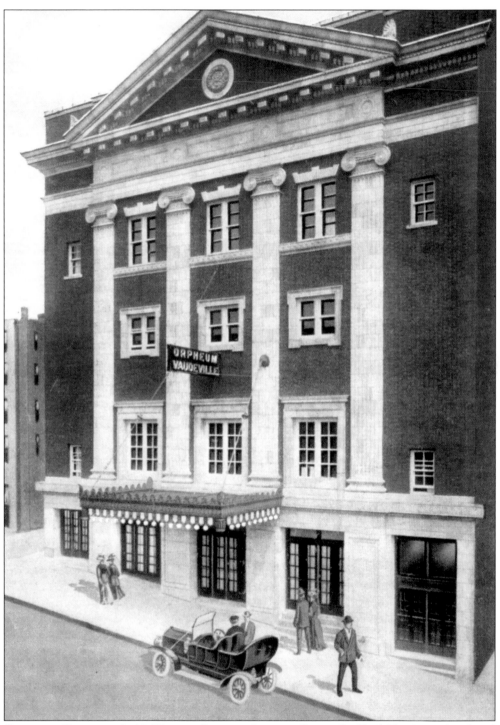

ORPHEUM THEATRE, 8–12 NORTH SECOND AVENUE EAST. Guilford Hartley, a local real estate developer, was the owner of this Classical Revival theater, which was built in 1910. Until 1925, it was the principal location for vaudeville productions. It closed in 1925, and sat empty until Mr. Hartley built the Norshor Theater around the corner on Superior Street.

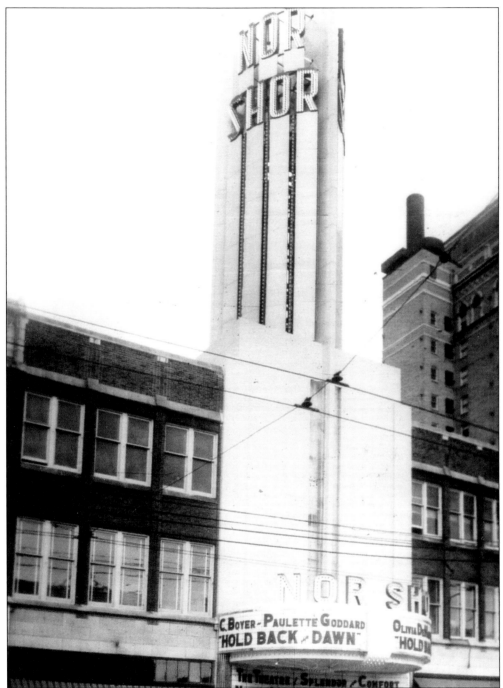

Norshor Theater, 207–213 East Superior Street. In 1940, Liebenberg and Kaplan, theater architects from Minneapolis, designed an Art Deco movie theater and included the old Orpheum Theater in its construction with a new entrance on Superior Street. They reversed the layout of the original theater and added a marquee. The 64-foot high tower which incorporated 3,000 lights was said to be visible from 60 miles. The Norshor closed in 1982, but has since been re-opened as part of the local arts and music scene.

FIRST POST OFFICE, SUPERIOR STREET AT FOURTH AVENUE EAST. There had been a post office in Oneota, but this was the first building actually constructed for a post office in downtown Duluth. It was on the outskirts of development when it opened in 1857. When the more substantial Hayes Block was built in 1870, the post office was transferred there. This early false front, wood structure was demolished in 1936, in spite of protests to save it.

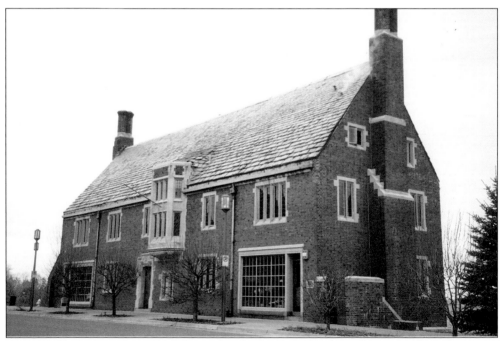

HARTLEY BUILDING, 740 EAST SUPERIOR STREET. Guilford Hartley was a Duluth pioneer with interests in transportation, mining, farming, lumber, and newspapers. He built his office building in 1914 on the edge of downtown Duluth, and he hired nationally prominent architect Bertram Goodhue to design the Tudor Revival brick building near the shore of Lake Superior. The Hartley family interests are still conducted in this building, which is listed on the National Register of Historic Places.

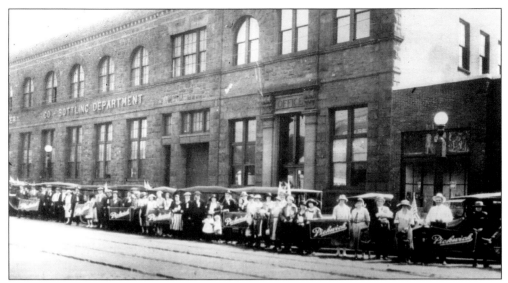

FITGER BREWING COMPANY, 600 EAST SUPERIOR STREET. Duluth's first brewery opened on Brewery Creek in the 1860s near this site, and in 1881, it became the Lake Superior Brewery. August Fitger, who was trained in Germany, became brewmaster in 1882, and the name changed to the Fitger Brewery Company. Buildings were added as the brewery expanded, and most present structures date from 1890 to 1920. The buildings are of brick and stone, and were designed by at least six different architects. During prohibition, Fitger's made soda pop and non-alcoholic beer. After prohibition and before World War II, the brewery produced 100,000 barrels of beer a year. Fitger Brewing Company closed in 1972, but has been adapted as an inn and shopping center, and is listed on the National Register of Historic Places.

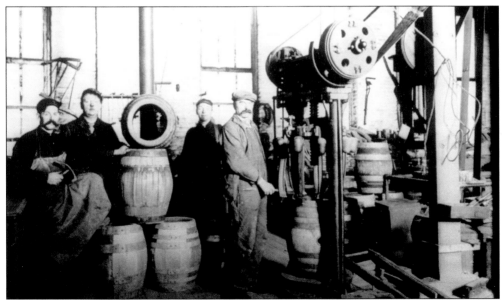

FITGER BREWING COMPANY WORKERS, 600 EAST SUPERIOR STREET. This interior photo of the brewery dates to about 1900, and is of unnamed brewery workers and equipment used in the process of brewing beer. Fitger's was known for Bavarian style beer, and some of the early brands were Pale Bohemian and Bavarian. Later brands included Rex and Twins Lager.

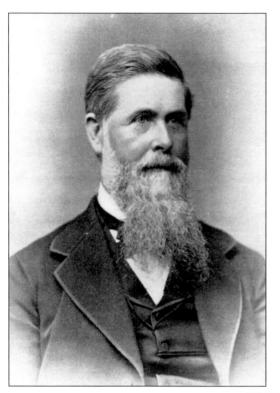

JAY COOKE IN 1875. Jay Cooke was a Philadelphia banker who had been the chief money raiser for the Union Army during the Civil War, and some credited him with winning the war for the Union. He first visited Duluth in 1866, and was impressed with its potential. He extended the Northern Pacific Railway to Duluth in 1869, encouraging many of Duluth's pioneers, "the Sixty-Niners," to settle here.

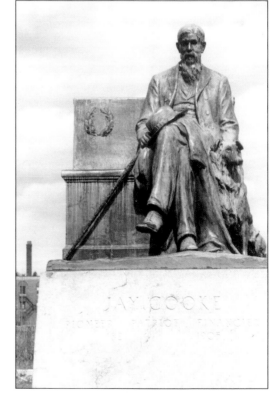

JAY COOKE STATUE, EIGHTH AVENUE EAST AND SUPERIOR STREET. Duluth was often called "Jay Cooke's town" in the 1860s and 70s because of his influence and the money he spent on its development. In 1869, Cooke owned 40,000 acres in or around Duluth. The bronze statue, by Henry Merwin Shrady of New York, was dedicated in 1921. It was donated by J.H. Harding, friend and associate of Jay Cooke.

WIELAND BLOCK, 26 EAST SUPERIOR STREET. Built in 1889 for $50,000, this commercial building was originally a furniture store, and the windows in the photo display the latest in home furnishings. The Wieland Block is best known historically as the home of the *Duluth News-Tribune* from 1901 until 1930. Duluth architect Oliver Traphagen designed this four-story brick and stone Romanesque Revival style building.

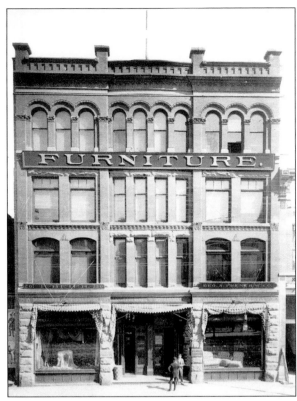

KITCHI GAMMI CLUB, 831 EAST SUPERIOR STREET. New York architect Bertram Goodhue designed this private social club in 1912. Its design is an eclectic combination of Elizabethan and Georgian styles. The brick and stone structure has an unobstructed view of Lake Superior, and features carved figures of Indians and a green slate roof.

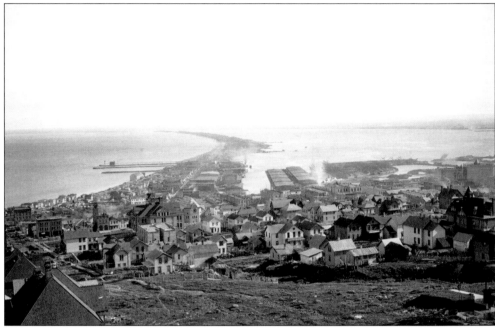

DULUTH AND MINNESOTA POINT, FROM THE HILLSIDE. This 1887 photo shows the still primitive ship canal, businesses, and homes on Minnesota Point. The Duluth hillside is in the process of being developed; it has been almost denuded of trees, and even the first brick buildings have started to sprout.

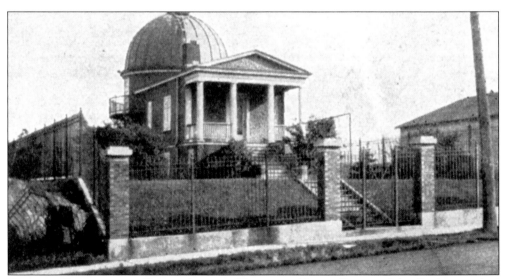

DARLING OBSERVATORY, NINTH AVENUE WEST AND THIRD STREET.-John Darling worked for the United States Army Corps of Engineers as a civil engineer, but his life's passion was astronomy. After his retirement, he used his own funds to build the observatory on city-owned land. It contained a nine-inch refractory telescope and planetarium. When Darling died in 1942, he willed the observatory to the University of Minnesota-Duluth campus with an endowment to run it. It continued to operate for about 20 years, but in 1963 the telescope and dome were removed. The telescope is on display at U.M.D. near the present planetarium.

Six

HILLSIDE

The hills which rise from the lake behind Superior Street were covered with a pine forest when the settlers came, but as trees came down for building materials and fuel, houses, schools, churches, and commercial establishments moved up the hillside. By the 1870s and 1880s, Second and Third Streets had a large residential area of apartments and homes. The Incline Railway opened in 1891, and made it possible for downtown workers to live at the top of the hill and commute to work. Gradually hospitals, parks, and public institutions were built above downtown while the presence of residential housing continued to create mixed neighborhoods.

ROGER MUNGER. Munger was one of the "Sixty-Niners," those who moved to Duluth in 1869 because of the coming of the railway. He was one of the most influential pioneers and is credited with many firsts: first saw mill on the harbor, first grain elevator, first coal dock, first opera house; he served on the first city council, first park board, first board of trade, and first school board. Munger had the contract for digging the canal, and was involved in the development of West Duluth as an industrial complex.

ROGER S. AND OLIVE MUNGER HOUSE, 405 MESABA AVENUE. The Mungers' home was built in the 1870s in the Italianate style with carriage house and gazebo. The carriage house, although remodeled, still stands. Munger died in 1913, and about 1930 his house was turned into apartments; it was demolished in 1955.

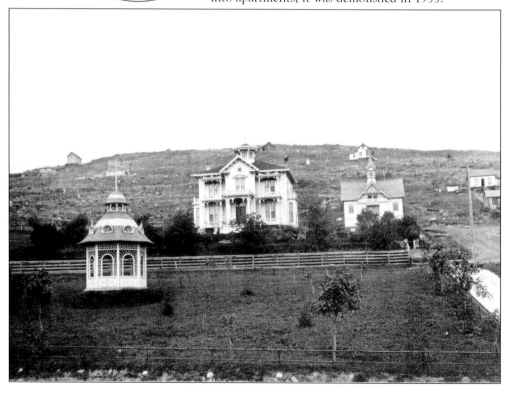

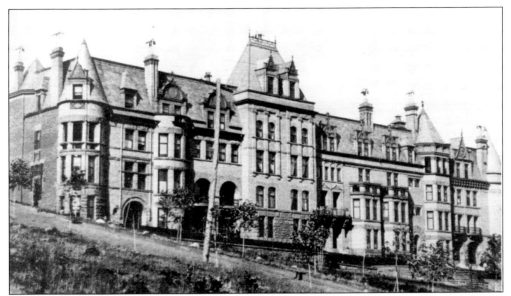

MUNGER TERRACE, 405 MESABA AVENUE. The Duluth architectural firm of Oliver Traphagen and Francis Fitzpatrick designed this apartment building on a steep hill overlooking the Duluth harbor in 1892 for Roger S. Munger whose 1870s Italianate house stood next door. Originally eight luxury townhouses with 16 rooms each, it was favored by wealthy Duluthians who wished to live close to downtown. But in 1915, as the residents moved to large homes in the East End, it was remodeled into 32 apartments. Features of the Chateauesque style used in Munger Terrace are towers, turrets, steeply pitched roof, dormers, decorative medallions, and finials. Munger Terrace was renovated in 1978, and is listed on the National Register of Historic Places.

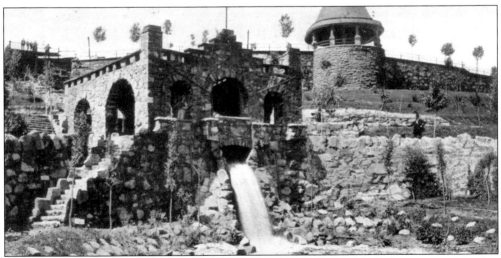

CASCADE PARK, BELOW MESABA AVENUE AT SIXTH STREET. Cascade Park was one of the first parks in Duluth, the city having purchased the land in 1869. However, it was not developed until 1895, when a sandstone wall, bell tower, and pavilion were built. The Clark House Creek (now underground) flowed through the park, and its waterfall can be seen in the photo. During a severe storm in 1897, the bell tower was smashed but was re-built in a different form in 1975, when the park was reduced in size to make way for the widening of Mesaba Avenue. Only 2.5 acres of the original 49 are still park land.

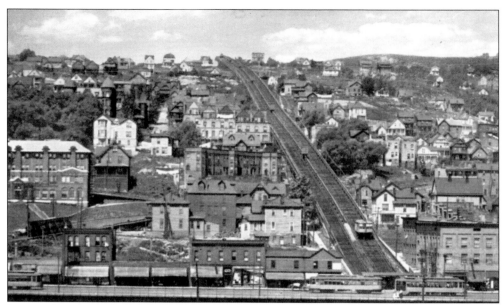

INCLINE RAILWAY, SEVENTH AVENUE WEST. The Duluth Street Railway Company operated the tramway, which began service in 1891, to carry people between downtown and the housing development at the top of the hill. Two sets of tracks were elevated on concrete footings, and cars were pulled by a steam engine in the powerhouse at the hilltop.

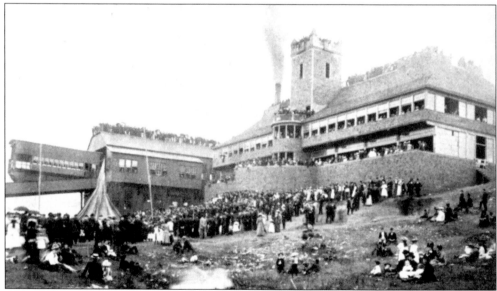

PAVILION AT TOP OF INCLINE RAILWAY. A year after service began, a pavilion was built at the top of the tramway. It included restaurants, a dance hall, and an auditorium. The pavilion was designed by Traphagen and Fitzpatrick and was a favorite place for picnics and for hot air balloon rides. In May, 1901, a fire which began in the power house destroyed the pavilion. Intense heat melted the cables, and the burning trolley raced down to Superior Street, hitting speeds nearing 150 miles an hour before it exploded into the Superior Street Station. No one was injured, but the pavilion was never rebuilt. The incline was continued in operation until 1939, when it was broken up and sold to a Japanese company as scrap which was used to build the Japanese war machine.

82

SACRED HEART CATHEDRAL, 201 WEST FOURTH STREET. The first Catholic church in Duluth was built in 1871 on this site donated by a land association. It was a small, wooden structure whose construction was supervised by missionary Father John Chebul. The church burned in 1892, and plans immediately began for a replacement. In July, 1896, the present brick, Gothic church was dedicated as the Cathedral of the Diocese of Duluth. In 1957, the Diocese built a new cathedral, and in 1985, the parish merged with St. Mary's and Sacred Heart closed. Community and parish support for preservation of Sacred Heart realized the creation of Sacred Heart Music Center whose members are restoring the former church as a venue for performing arts. Sacred Heart Cathedral is listed on the National Register of Historic Places.

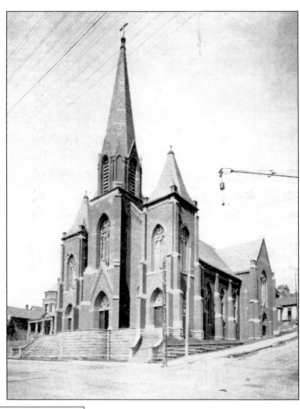

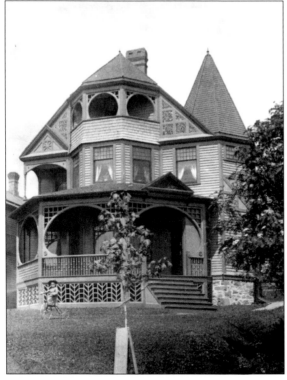

LUKE AND MARY MARVIN HOUSE, 123 WEST THIRD STREET. About 1882, as Duluthians were beginning to populate the steep hillside above the downtown, an unknown architect or talented carpenter designed this picturesque house for Luke and Mary Marvin. Arched porch openings with lattice work decorate the home of this early Duluth pioneer family who moved from St. Paul in 1861, over the old stage route which followed the Military Road to Superior, Wisconsin. They then came over the St. Louis River by ferry to the struggling young village of Duluth. Mary Marvin may have been the first European woman to travel this primitive trail through forests and over corduroy roads. Luke Marvin was an early register at the land office and investor in a lumber company, and spent time in St. Paul convincing legislators to support development of Duluth.

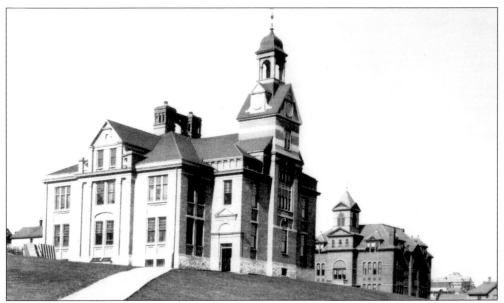

ORIGINAL WASHINGTON SCHOOL, SECOND STREET BETWEEN LAKE AVENUE AND FIRST AVENUE EAST. Built in 1882, this elementary school stood where Central High School was built eight years later. It was designed by prominent Minneapolis architect LeRoy Buffington, and was of brick with stone trim. It cost $50,000 to build, and was called the "Pride of Duluth." Unfortunately, in 1890 when a larger high school was needed, this was demolished. The building behind Washington School in this photo was the Liberty School, a high school built in 1886, and renamed Washington School when Central High School opened in 1892. It closed in 1921, and was used as school district administration offices until 1975. It was demolished in 1976.

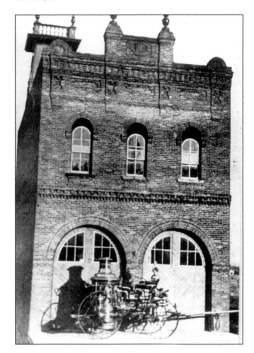

ENGINE HOUSE, 22 EAST SECOND STREET. In 1870, a group of Duluth citizens volunteered to become Duluth's first fire company. The engine house was a small wooden structure built at the base of Minnesota Point to house a steam powered fire rig. The fire department had its most embarrassing day when the building burned to the ground before the new steam engine could be used. In 1872, this brick engine house was built for $500. It served until Engine House No. 1 was built on Third Street. But the early brick fire hall still stands, minus the bell tower, arched doors, and decorative brickwork.

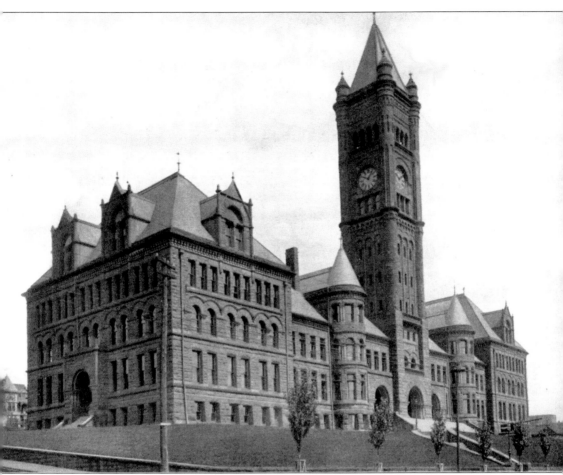

CENTRAL HIGH SCHOOL, LAKE AVENUE, AND SECOND STREET. Central is one of Minnesota's finest examples of Richardsonian Romanesque architecture. The Duluth firm of Emmet Palmer and Lucien Hall designed the school which opened in 1892. It was built of Lake Superior brownstone with a massive square clock tower which rises 230 feet. Ornate stone carvings of eagles, cherubs, and gargoyles decorate the structure. A school tradition was to allow graduating seniors to climb into the tower's belfry to look out over the city, and many left names and messages in graffiti. Central closed in 1971, with the completion of a new Central High School on the top of the hill, and the building was converted to the school district's administrative offices. To many, Central High School, as it sits poised on the hill looking out over Lake Superior, is as much a symbol of Duluth as is the Aerial Lift Bridge.

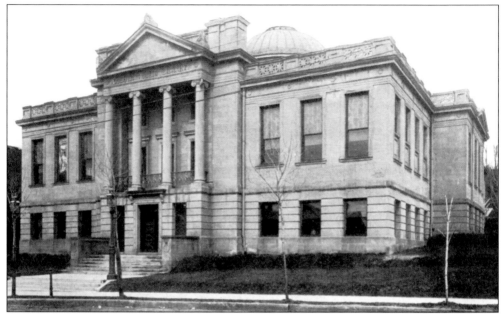

DULUTH PUBLIC LIBRARY, 101 WEST SECOND STREET. The first Duluth Public Library was on the second floor of the Masonic Temple Opera Block. Increasing demands for space and services caused the library board to construct a facility for library quarters only. Andrew Carnegie donated $25,000, and other gifts paid for construction of the Neo-Classical design by Duluth architect Adolph Rudolph. It is a two-story sandstone and brick building with decorative carvings and a central dome. In 1927, an addition was added to the rear of the building. The library served the Duluth community until 1980, when a new library was completed on West Superior Street. The "Carnegie Library" is now an office building, and is listed on the National Register of Historic Places.

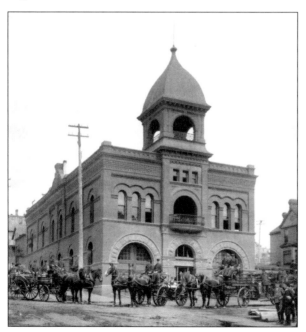

ENGINE HOUSE NUMBER 1, 101 EAST THIRD STREET. When the growth of the Duluth Fire Department required a hall larger than the brick structure on Second Street, the city hired Oliver Traphagen to design this red brick and stone building. It was built in 1889, and although the imposing bell tower was removed in 1910, the building retains much of the carved brownstone ornamentation. The Engine House closed in 1918, and has been used for maintenance and storage by the Duluth School District. Even without its distinctive tower, the firehouse is listed on the National Register of Historic Places.

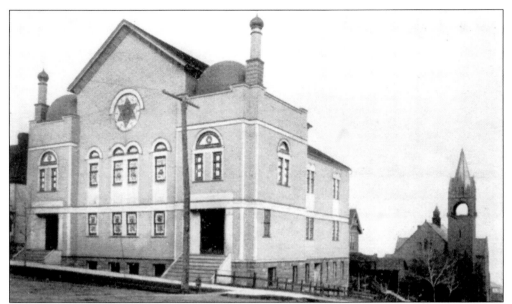

ADAS ISRAEL SYNAGOGUE, 302 EAST THIRD STREET. Jewish immigration to Duluth was heaviest in the 1880s and 90s, although some Jews were here by 1870. The Orthodox Jews organized as a congregation about 1885, purchased a house in Canal Park, and converted it into a synagogue. By 1899, the Adas Israel congregation organized and built this synagogue, first used for worship in 1902.

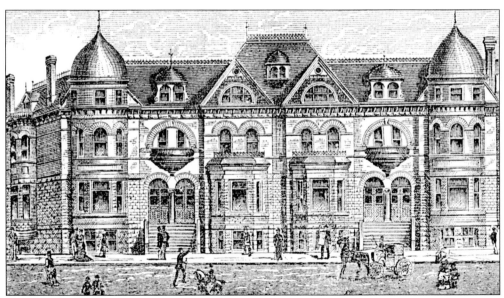

SALTER TERRACE, 301–307 EAST THIRD ST. Rev. Charles Salter was the first pastor of Pilgrim Congregational Church and the first chaplain of the Bethel Association, a missionary society to serve sailors, loggers, miners, and their families. In 1887, Salter and his wife Maria commissioned Oliver Traphagen to build the four townhouses of Salter Terrace. They lived there with their sons and daughters until 1892. The Romanesque Revival building is essentially unchanged on the exterior from the sketch, which appeared in an 1888 Duluth newspaper. The four townhouses were later converted to more than 20 apartments.

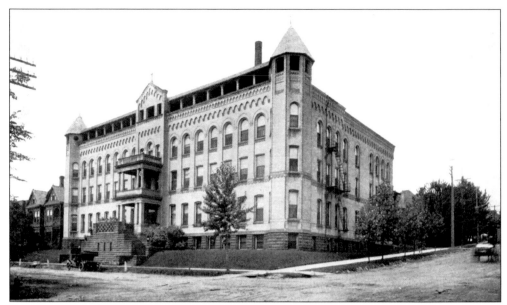

ST. MARY'S HOSPITAL, 404 EAST THIRD STREET. The Benedictine Sisters opened the first St. Mary's in 1888 in Lincoln Park, but Duluth's burgeoning population required a larger facility which opened in 1911. Additions to the hospital from 1920 to the 1990s have hidden the original facade, as shown in this 1909 photo.

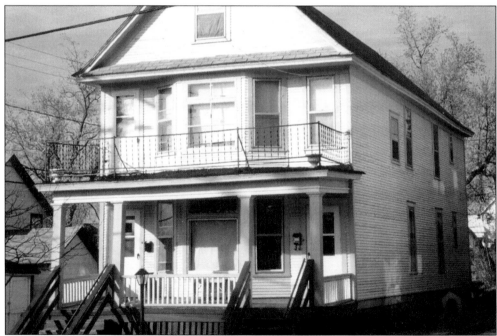

ABE AND BEATRICE ZIMMERMAN HOUSE, 519 NORTH THIRD AVENUE EAST. This house was the first home of Robert Allen Zimmerman, who became the singer Bob Dylan. He was born in Duluth's St. Mary's Hospital, May 24, 1941. He lived in this house and attended Nettleton School until the family moved to Hibbing in 1947. Abe Zimmerman, Dylan's father, was a supervisor for Standard Oil Company.

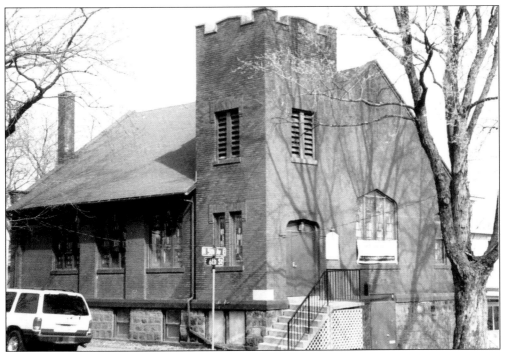

ST. MARK AFRICAN METHODIST EPISCOPAL CHURCH, 530 NORTH FIFTH AVENUE EAST. The first black congregation, founded in 1890, met in various locations until they built a stone basement here in 1900. They could not afford to complete the building until 1913, when the upper story and tower were finally added. There were only 12 members in 1900, and the membership may never have exceeded 100. The church has been a center of religious and social functions for Duluth's African-American community since its construction, and is now listed on the National Register of Historic Places.

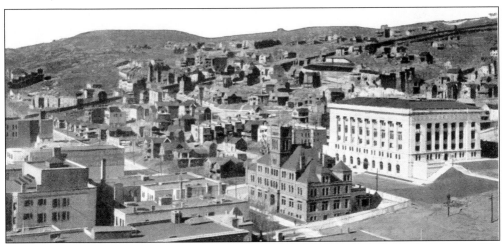

BIRD'S-EYE VIEW OF HILLSIDE. This view of the Duluth hillside dates to about 1910. The courthouse, the large white classical building on the right, was built in 1909, and the building in front of it is the 1894 government building, which stood there until 1934. In the background are visible the tracks of the Incline Railway which took residents from Superior Street up to Duluth Heights. At this period much of the hillside was still undeveloped.

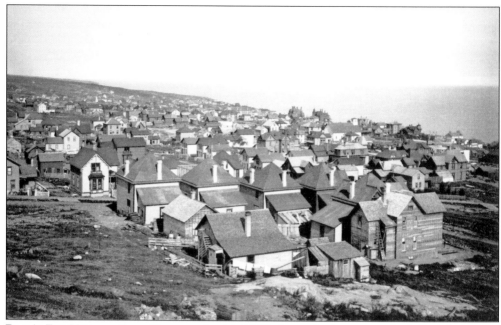

BIRD'S-EYE VIEW OF EAST DULUTH. In this 1887 photo, the houses on the hillside belong to workers, but in the background against the lake can be seen the large, Queen Anne style houses in Ashtabula Heights, the first established neighborhood in the East End of Duluth.

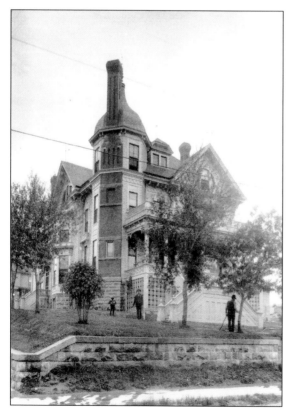

JAMES AND CAROLINE RAY HOUSE, 401 EAST SECOND STREET. James D. Ray was one of the earliest pioneers at the head of the lake, moving to Superior in 1855. He was involved in platting the village of Portland in 1856. That was an area, now part of east Duluth, which included Ashtabula Heights, a neighborhood extending from about Third Avenue East to 10th Avenue East. It was named after Ray's hometown of Ashtabula, Ohio. He worked for harbor improvement, served on the first city council, and was involved in digging the canal. The Rays' Queen Anne style house was one of the first built in Ashtabula Heights about 1880, and was demolished in the early 1940s.

Seven

EAST END

As Duluth's downtown and the hillsides filled with commercial buildings and apartments, merchants and professionals began to move east, at first into Ashtabula Heights on Second and Third Streets beyond Third Avenue. Then the growing middle class and the wealthy built homes, many of them considered mansions, farther east. By 1920, those homes reached to 40th Avenue East, an area which is filled with the period revival houses so popular at that time. Architects designed many of the houses in the East End neighborhoods, including churches and schools, but there are no industrial and few commercial buildings.

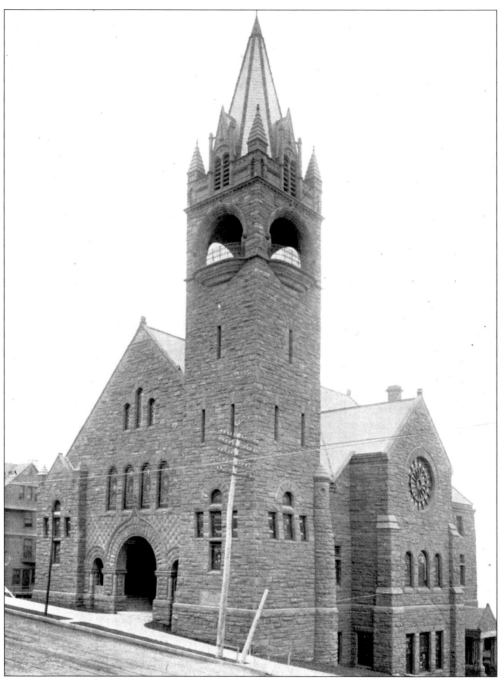

FIRST PRESBYTERIAN CHURCH, 300 EAST SECOND STREET. This may be the finest Romanesque design in Duluth. Architects Traphagen and Fitzpatrick designed the building using brownstone from Lake Superior quarries. The congregation's first church stood diagonally across the intersection. This structure opened in 1891, and features a 125-foot bell tower with turrets. Other features include a Rose window on the avenue side, a segmented arched entrance, and three Tiffany windows. The architectural success of this church is due in large part to its simplicity of design.

Josiah and Rose Ensign house, 504 East Second Street. Attorney Josiah Ensign settled in Duluth in 1870, and immediately established a law practice and entered into city politics. Judge Ensign was highly respected as an honest and fair judge and as a great supporter of the City of Duluth. He served on the city council and as mayor during the 1880s. The Ensign house was built about 1880 in Ashtabula Heights. Ensign and his wife lived here until their deaths in 1923 and '24. The house was demolished in the 1930s for the construction of Miller-Dwan hospital.

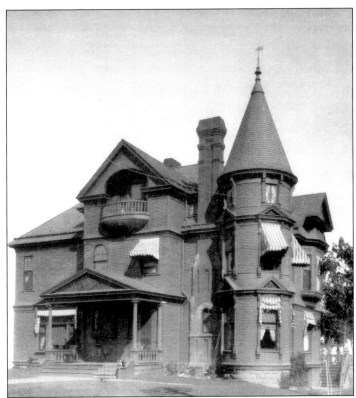

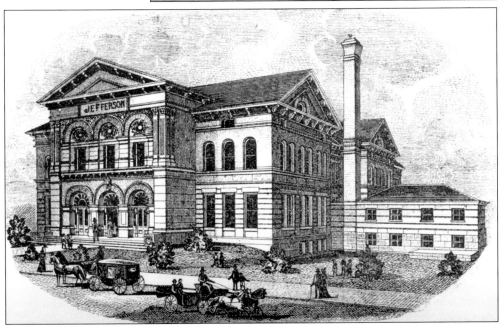

Jefferson School, Second Street, between 9th and 10th Avenue East. An earlier school, called the Portland School, stood on this block from 1883 until 1892. Jefferson school, designed by architect Edwin Radcliffe, opened in 1893 and closed in 1983. It has since been converted to Jefferson Square Apartments.

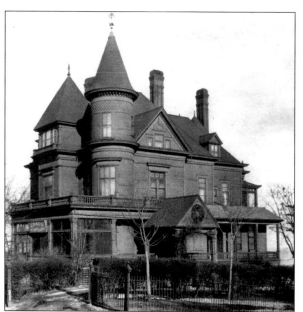

HENRY AND ALAMEDA BELL HOUSE, 600 EAST SECOND STREET. Henry Bell was a partner in an early private bank, Bell and Eyster's. In 1887, he and his wife commissioned Oliver Traphagen to design an elegant Queen Anne style house in Ashtabula Heights, the upscale neighborhood of the time. Traphagen produced this 3.5-story house with two round towers, one square tower, gables, dormers, and decorative brick chimneys. When the Bell and Eyster bank failed in 1893, the Bells moved to Oakland, California. By 1930, the house was a mortuary and has since been remodeled with wide siding and removal of all decorative elements.

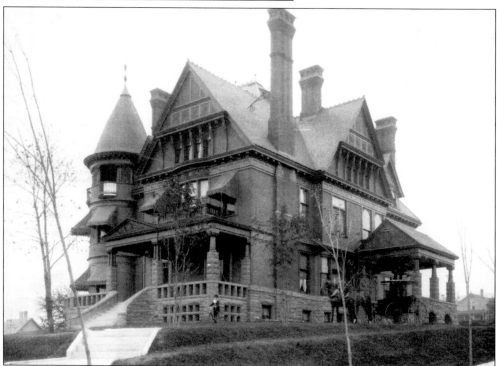

CLINTON AND KATE MARKELL HOUSE, 325 EAST SECOND STREET. In 1890, Oliver Traphagen designed this large Queen Anne house for the Markells. It had highly decorated gables with braces, four extremely tall chimneys, and a three story round corner tower. Clinton Markell was an early pioneer who partnered with Roger Munger to build the 1883 Grand Opera House. He was involved in real estate and was the second mayor of Duluth, taking office in 1871. Later residents of this house were Robert and Sophia Whiteside. Robert Whiteside was involved in timber and mining. The Markell house was demolished in 1961.

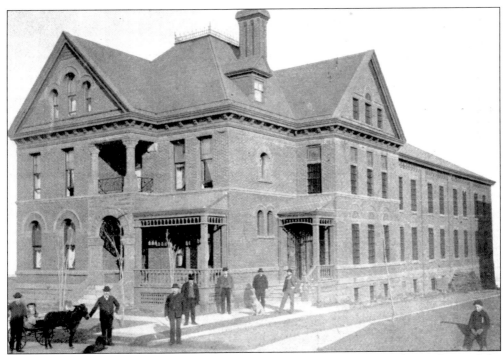

St. Louis County Jail, 614 East Third Street. In 1889, Oliver Traphagen designed the red brick county jail that also held the sheriff's living quarters. The sheriff and his family lived in the front section of the building and the rear held cells. The sheriff's wife cooked meals for the prisoners. In 1923, a new county jail was completed and this building became Hearding Hospital, which closed in 1945. It was then remodeled into a rooming house and served as such until it was demolished in 1954.

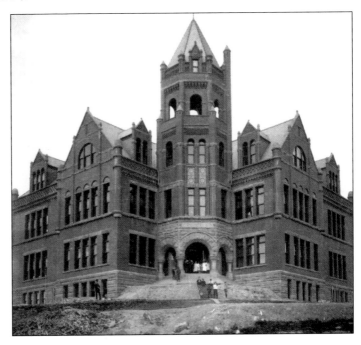

Endion School, 1801 East First Street. Endion School was constructed in 1890 to serve the growing East End neighborhood where former downtown residents were beginning to build homes. Adolph Rudolph designed it in the Romanesque Revival style. Originally the school had a tower with open belfry, but it was taken down in 1970. Endion School closed in 1977, but re-opened a few years later as Endion School Apartments. It is listed on the National Register of Historic Places.

ST. PAUL'S EPISCOPAL CHURCH, 1710 EAST SUPERIOR STREET. The Episcopal Church at the Northwest corner of Second Street and Lake Avenue, built in 1869, was the first church in Duluth. Jay Cooke was one of the major contributors to the church, and therefore it was often called "Jay Cooke's Church." The congregation built this later church in 1913, in the style of English Gothic churches. Nationally prominent architect Bertram Goodhue of New York City designed it. The adjoining parish hall was built in 1929.

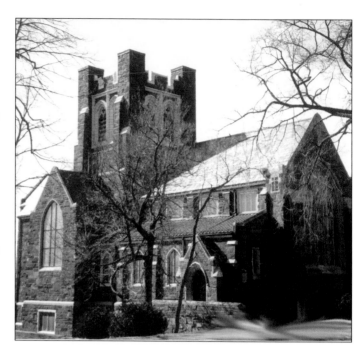

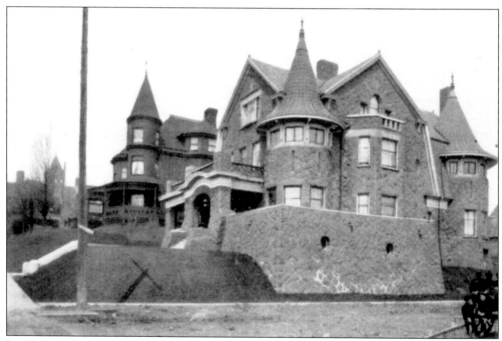

LESLIE AND OPHELIA LEITHHEAD HOUSE, 16 SOUTH 18TH AVENUE EAST. This Romanesque Revival style house was designed by William Hunt and built in 1902. The fortress-like appearance is created by the use of brownstone with two large round dominating towers. The house behind the Leithhead house is that of Ophelia Leithhead's father, Joseph Sellwood, who built the Leithhead house as a wedding present for his daughter. Leslie Leithhead was president of Leithhead Drug Company, one of Duluth's wholesale firms which sold drugs, chemicals, and patent medicines.

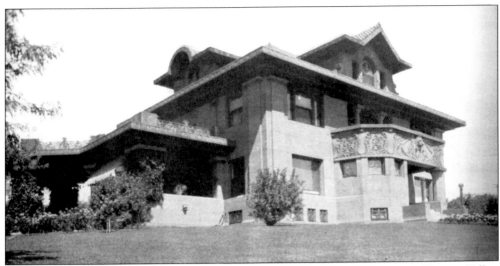

GEORGE AND CHARLOTTE CROSBY HOUSE, 2029 EAST SUPERIOR STREET. I. Vernon Hill, a young and imaginative architect, introduced a new, eclectic architectural style in his Duluth houses. He took the basic square or rectangular form and dressed it with flared dormer gables and classical detailing. In the Crosby house of 1902, Hill created walls of huge sandstone blocks with stone carvings for the first of his "ornamented cube" houses. Of special note is the carved brownstone lion's head over the entrance. Crosby was a mining pioneer who discovered several iron ore ranges. He developed the Cuyuna Range, and founded the town of Crosby, Minnesota.

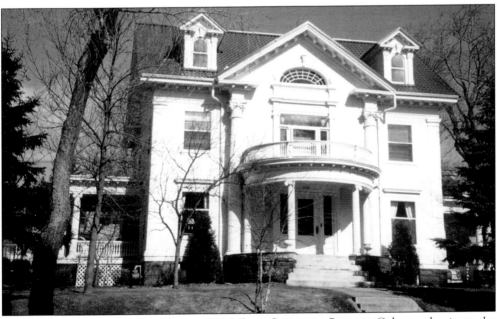

FRANK AND JENNIE BREWER HOUSE, 2215 EAST SUPERIOR STREET. Columns dominate the facade of this Georgian style house, built in 1902 and designed by Emmet Palmer and William Hunt. The curved portico, side porch, and porte-cochere are supported by columns, which are also found on corners and dormers. In addition, two story Corinthian columns support the front pediment. Brewer was a partner in the Duncan and Brewer Lumber Company and president of Great Northern Power Company.

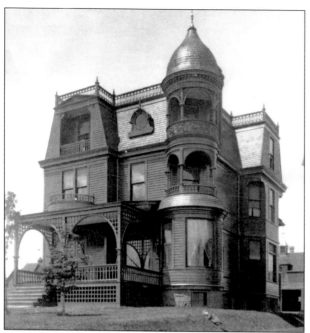

WILLIAM AND AMELIA SHERWOOD HOUSE, 1125 EAST SUPERIOR STREET. This unusual house, with a Mansard roof, round corner tower, iron roof cresting, and several open porches, was designed by Oliver Traphagen and built in 1885. Sherwood was in the real estate business. The property was a rooming house from the late 1930s until it was demolished about 1949.

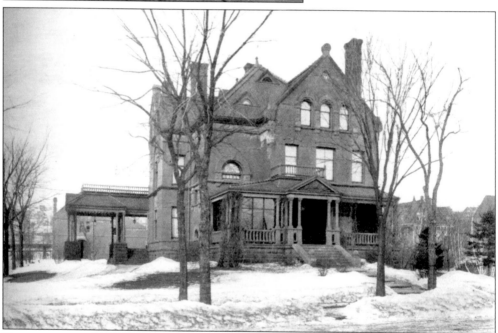

GUILFORD AND CAROLINE HARTLEY HOUSE, 1305 EAST SUPERIOR STREET. Guilford was a Duluth businessman with interests in timber, mining, farming, real estate, politics, the wholesale grocery trade, and transportation. He was owner of a Duluth newspaper, and a founder of the Northland Country Club. The Hartley name survives with buildings, houses, and parks. The home the Hartleys built in 1889 was a Romanesque mansion, 3.5 stories tall, with porches, a porte-cochere, and a carriage house. It was the first house in Duluth with electricity, and had an early attempt at air conditioning. Duluth architect Oliver Traphagen was commissioned to design the house which was demolished in 1954.

OLIVER AND AMELIA TRAPHAGEN HOUSE, 1511 EAST SUPERIOR STREET. Oliver G. Traphagen came to Duluth from St. Paul in 1881 as a carpenter. He quickly proved his artistic skills, and by 1885 was designing Duluth buildings, first with St. Paul architect George Wirth, then alone, and finally in partnership with Francis Fitzpatrick. Together they built many of Duluth's finest buildings. His own family's house was built in 1891 of brick and red sandstone. It was a side-by-side duplex where the Congdon family later lived while Glensheen was being built. The Traphagen house is listed on the National Register of Historic Places.

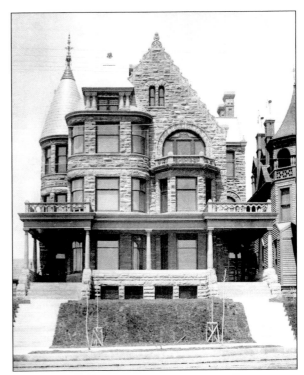

OLIVER AND AMELIA TRAPHAGEN. Only four years after building their home, Oliver and Amelia Traphagen moved to Honolulu, Hawaii, where he designed many of Hawaii's most important buildings. After the 1906 earthquake and fire in San Francisco, the Traphagens moved again. He may have expected to take part in the rebuilding of San Francisco, but he designed only one building there. Both Traphagens died in Alameda, California, she in 1931 and he in 1932.

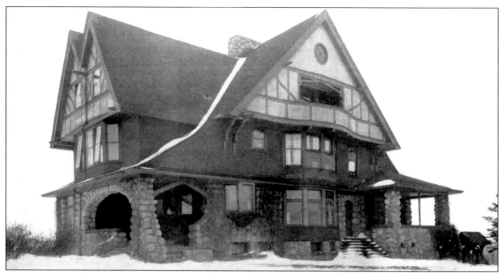

FREDERICK AND KATHERINE PATRICK HOUSE, 2306 EAST SUPERIOR STREET. Duluth architect I. Vernon Hill influenced the city's residential architecture for years after his early death at age 36. In the picturesque Patrick house he employed stone, half-timbering, and steep gables in the Tudor Revival style. Carved eagle heads on brackets support the third floor gables. Frederick Patrick founded F.A. Patrick and Company, a wholesale dry goods firm that specialized in woolen clothing and was known for its fine quality mackinaws. The Patricks lived here until the 1930s.

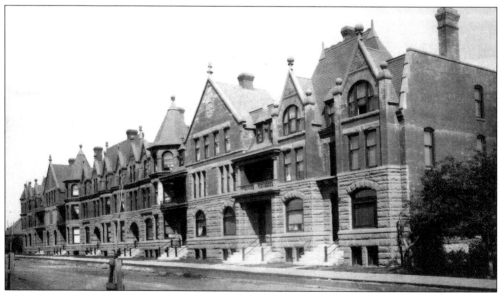

CHESTER TERRACE, 1200 BLOCK OF EAST FIRST STREET. Built in 1890, and designed by Oliver Traphagen and Francis Fitzpatrick, this row of 15 townhouses is another example of the Richardsonian Romanesque Revival style of architecture. Constructed of brick and brownstone, it features towers, turrets, gables, and finials. When built it was called H.A. & F.W. Smith Terrace, but soon was renamed for Chester Creek, which flowed to Lake Superior past the building. The exterior of Chester Terrace is unaltered from its 1890 appearance, and is listed on the National Register of Historic Places.

MATTHEW BURROWS HOUSE, 1632 EAST FIRST STREET. The firm of Charles McMillen and Edwin Radcliffe designed this Queen Anne style house. It was built in 1892 for Burrows, who apparently was a bachelor, at a time when merchants and professional people were moving to Duluth's east end. He owned the Great Eastern Clothing Company in downtown Duluth. After Burrows returned to his native Canada in about 1905, the house became a boarding house for women only, then for both men and women, and finally it was converted to apartments. It has since been restored and is a popular bed and breakfast.

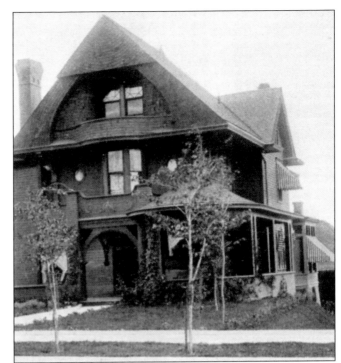

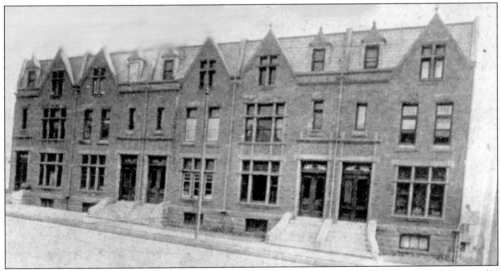

PHILADELPHIA TERRACE, 1412–1420 EAST SUPERIOR STREET. Although not as architecturally significant as other townhouse complexes they designed, this one by Traphagen and Fitzpatrick was built in 1890 as homes for professionals who were leaving downtown residences. It had five townhouses, each with a finial-topped gable surmounting the entrances. Architect Francis Fitzpatrick lived here from 1890 until 1896. Fitzpatrick worked as an architect in Minneapolis until Oliver Traphagen invited him to become a partner in Duluth's most prestigious architectural office. After Fitzpatrick left Duluth he became an internationally recognized authority on fire prevention, and was the originator of fire prevention activities, such as "Fire Prevention Week," each October. The Philadelphia Terrace became the Hamilton Hotel by 1930, and was demolished about 1984.

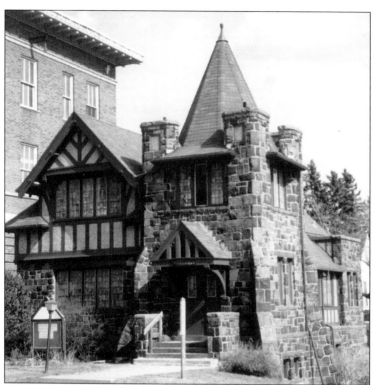

FIRST UNITARIAN CHURCH, 1802 EAST FIRST STREET. Unitarianism had begun in the United States when groups of people broke away from the Congregational Churches of New England. The church emphasized freedom of belief and democratic participation in church affairs. Duluth's Unitarians organized in 1877, and this Tudor Revival church was designed by Anthony Puck and built in 1910.

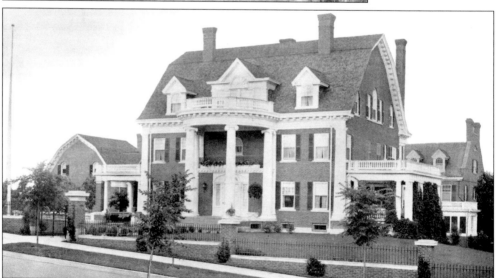

WILLIAM AND FANNY OLCOTT HOUSE, 2316 EAST FIRST STREET. This was built in 1904, and designed by Duluth Architect William T. Bray in the Georgian Revival style. Olcott was a mining engineer and was president of the Duluth, Missabe, and Northern Railway before serving as president of Oliver Mining Company from 1909 to 1928. Oliver was the largest and most influential mining company on the northern Minnesota Iron Ranges. The house is the most impressive Georgian Revival in Duluth, and features a two-story portico with immense columns and a matching carriage house. During the 1990s, it was restored and is now a thriving bed and breakfast.

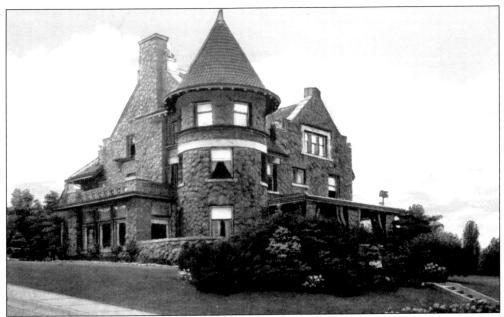

HENRY AND LUCY MEYERS HOUSE, 2505 EAST FIRST STREET. The Meyers house is the best residential example of the Romanesque Revival style of architecture in Duluth. Myers was an investment banker. Its black basalt stone came from the excavation for nearby 24th Avenue East, and gives the heavy, massive feel characteristic of this style. It was designed by William T. Bray and Carl Nystrom, and built in 1909.

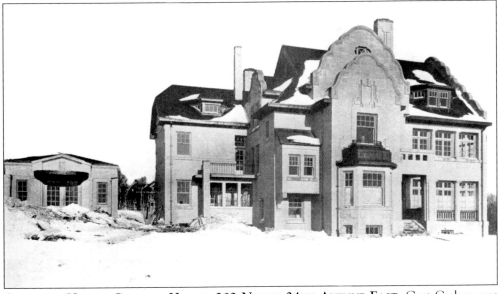

GUST AND HANNA CARLSON HOUSE, 202 NORTH 24TH AVENUE EAST. Gust Carlson was an early miner who explored the Mesabi and Cuyuna iron ranges in northern Minnesota. He was a supporter of the development of taconite processing in the 1920s, and also had extensive interests in zinc and copper mining in Idaho, Montana, and Arizona. The Carlsons' house was designed by A. Werner Lignell, and built in 1910. It is an unusual architectural style of gray brick with Flemish (scalloped) gables.

103

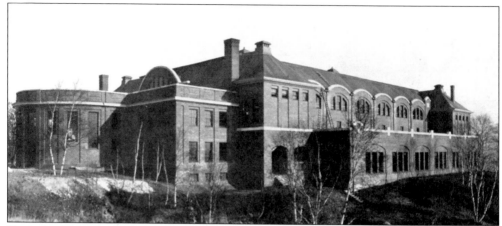

DULUTH CURLING CLUB, 1338 LONDON ROAD. The Duluth Curling Club was organized in 1891, and the first stone was thrown on Christmas Day on the ice of Lake Superior. Rinks were built in several locations before the Curling Club building opened in 1913. With 12 sheets of curling ice, it was the largest in the world. The second floor had ice for skating and hockey in the winter and provided space for roller-skating in the summer. The Curling Club moved to the Duluth Entertainment and Convention Center in 1976, and the vacant building burned in 1984.

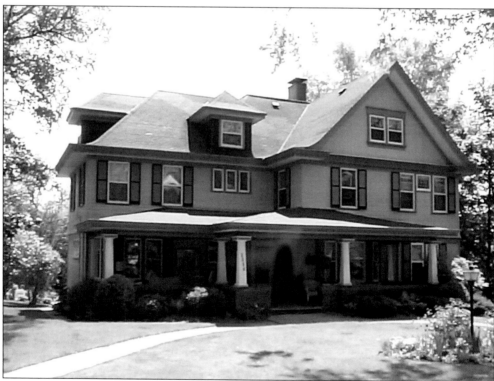

GEORGE AND ELEANOR SWIFT HOUSE, 2320 EAST FIRST STREET. Built in 1893 for the Swifts, this house was originally next to the roadway, but in 1910 it was moved back approximately 30 feet and the left wing was added to the original structure. The architect and contractor was Irving Spear who lived nearby on Branch Street. George Swift was secretary-treasurer of the Oliver Mining Company. The house has been restored and is still occupied as a single family residence.

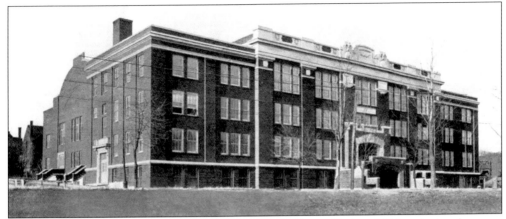

DULUTH NATIONAL GUARD ARMORY, 1305 LONDON ROAD. Built in 1915 as the headquarters for the Minnesota National Guard unit in Duluth, it also served as the cultural and recreational center for many years. Designed by architects Clyde Kelly and Owen Williams, it is a Classical style building of brick and concrete. In 1977, the National Guard moved to a new facility, and the City of Duluth claimed the property and has since used it for street maintenance equipment and storage.

HORSE FOUNTAIN, ROSE GARDEN ON LONDON ROAD. Built in 1905 to honor George C. Stone, by his daughter, the fountain originally stood in front of the Kitchi Gammi Club at the junction of Superior Street and London Road. It was a horse-watering trough and had a lapping cup for dogs at the base. When automobiles replaced horses, the fountain was moved a few blocks east. It was moved a third time to its present home in the Duluth Rose Garden when Interstate Highway 35 was completed.

LEIF ERICSON STATUE, LONDON ROAD ABOUT 12TH AVENUE EAST. The Leif Ericson statue was sponsored by the Norwegian-American League to honor the thousands of Norwegians who settled in Northern Minnesota. The bronze statue was designed by John Karl Daniels and placed here in 1956.

LEIF ERICSON BOAT, LEIF ERICSON PARK, LONDON ROAD. In 1926, this boat crossed the Atlantic Ocean from Norway to Boston, retracing the route of the boat which brought Vikings to the new world 1,000 years ago. Bert Enger purchased and donated the boat to Duluth. It arrived in Duluth on June 27, 1927. It deteriorated for many years, but in the 1990s it was restored by a group of dedicated volunteers, and is now on exhibit in Leif Ericson Park.

DULUTH STATE TEACHERS COLLEGE, 23RD AVENUE EAST AND FIFTH STREET. The building on the left, commonly called "Old Main," opened as Duluth State Normal School in 1902. It was designed by Duluth architects Palmer, Hall, and Hunt. Torrance Hall, in the center, built in 1909, and Washburn Hall, on the right, built in 1907, were constructed as dormitories. State Architect Clarence Johnston designed both. In 1947, the Teachers College became a branch of the University of Minnesota. A large campus, the present U.M.D., was built a few blocks away. Torrance and Washburn still stand, but Old Main was destroyed by fire in 1993. The arched entrances were saved and became part of a Duluth park.

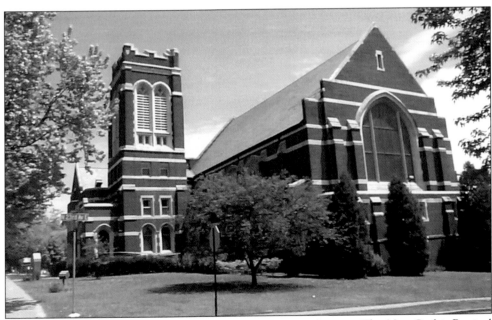

PILGRIM CONGREGATIONAL CHURCH, 2310 EAST FOURTH STREET. This Neo-Gothic Revival church was dedicated in 1917 and was the congregation's third place of worship. The building was located in the East End residential neighborhood. The two earlier buildings had been located in Duluth's downtown. Architects were Frederick German and Leif Jenssen. Pilgrim Congregational Church has many outstanding stained glass windows, five of which were made by the Louis C. Tiffany Studios in New York.

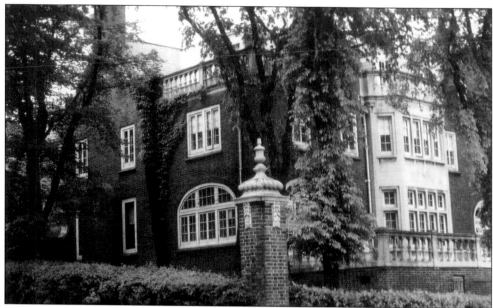

JOHN AND JULIA WILLIAMS HOUSE, 2601 EAST SECOND STREET. Chicago architect Frederick Perkins designed this house for the Williams family in 1912, but it is more well-known because author Sinclair Lewis lived here from 1944–46. The brick Tudor style house has 30 rooms and a regulation size bowling alley in the basement. Lewis lived here for just two years, but it is believed that some of the characters in his novels were based on people he knew in Duluth.

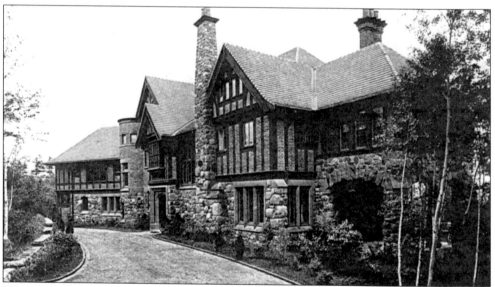

WARD AND HELEN AMES HOUSE, 1618 VERMILLION ROAD. Although John Millen, the manager of the Alger Smith Lumber Company, commissioned Frederick German to build this English manor house in the Tudor Revival tradition, the Millens lived here just a short time before selling it to Ward and Helen Ames. The stone, brick, and half-timbered house was constructed in 1912, with a gatekeeper's house on a large estate surrounded with iron fencing. Ward Ames, Jr. was a founder of the McDougall-Duluth Shipyards and an executive with Barnes-Ames Company, grain shippers.

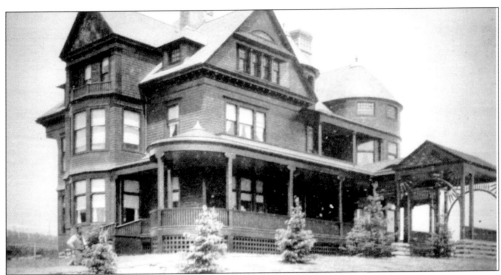

MATTHEW AND LUCY HARRISON HOUSE, 2605 GREYSOLON ROAD. This Shingle style house was built in 1889 for only $11,000, for Matthew and Lucy Harrison. He was a Duluth attorney who was involved in early mining with the Merritt Brothers. He was related to two other Harrisons, both of whom served as president of the United States: William Henry for only 30 days in 1841, and his grandson, Benjamin from 1889 to 1893. Matthew Harrison lived in this house for only two years before he died. From 1896 to 1900, it was used as a private college preparatory school. Albert and Julia Marshall lived here from 1901 until 1932. He was president of Marshall-Wells. The Harrison house was razed about 1935.

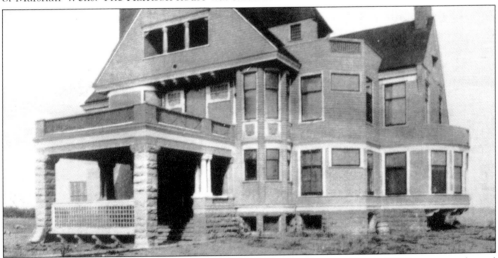

ALONZO AND JULIA WHITEMAN HOUSE, 2732 LONDON ROAD. Alonzo Whiteman graduated from Columbia College in New York City with a law degree and came to Duluth in 1881 to oversee his wealthy father's land holdings. He became a banker and was elected to the State Senate at the age of 26. In 1890, Whiteman built an impressive shingle style home designed by Oliver Traphegen on the shore of Lake Superior. Whiteman had a gambling addiction and found that he could successfully forge other's signatures. He left Duluth about 1894, with Pinkerton men close on his coat tails. After serving several jail terms, he returned to his hometown in New York State, and worked in the poor house until his death in the 1930s. The Whiteman house was demolished about 1912.

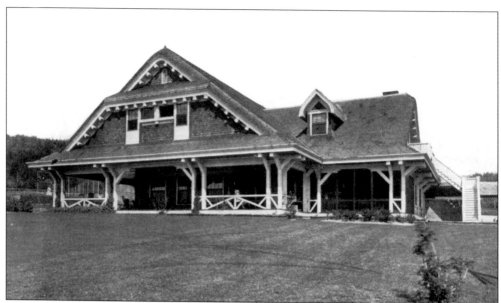

EARLY NORTHLAND COUNTRY CLUB, 3901 EAST SUPERIOR STREET. The first clubhouse built in 1899 was a low building with an open porch in the Arts and Crafts style of architecture. It burned in the 1918 Cloquet-Moose Lake forest fire, which reached the outskirts of Duluth.

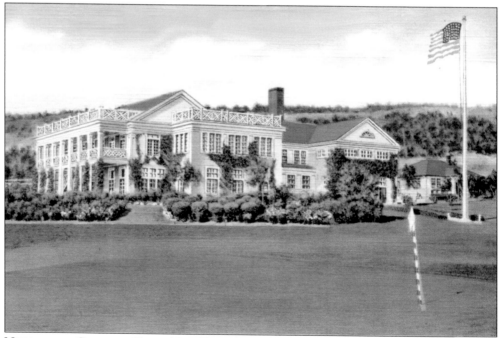

NORTHLAND COUNTRY CLUB, 3901 EAST SUPERIOR STREET. The present clubhouse, a large colonial style building, was constructed in 1919. Until 1927, part of the golf course was across Superior Street and signs were posted on the street to warn the public about flying balls.

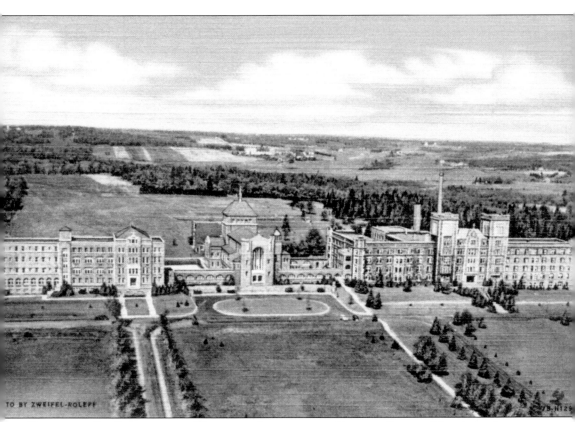

COLLEGE OF ST. SCHOLASTICA, KENWOOD AVENUE, AND COLLEGE STREET. The photo shows the earliest buildings of the college constructed by the Sisters of the Order of St. Benedict. St. Scholastica began as a high school called Sacred Heart Institute in 1898. The building on the right, Tower Hall, was constructed in 1909. By 1913, the school became a junior college, and by 1924, a four-year college for women. The building on the left was Stanbrook Hall, a student residence, and in the center stands the chapel built in 1938. Today the college has expanded its campus to cover the vacant land in the photo.

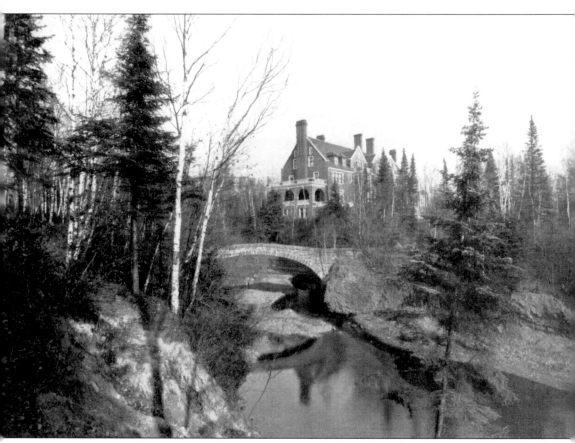

GLENSHEEN, 3300 LONDON ROAD. Chester and Clara Congdon commissioned St. Paul architect Clarence Johnston to design this Jacobean manor house on the shore of Lake Superior. It took three years, 1905–1908, to complete the estate which included a carriage house, boat house, gardener's cottage, tennis courts, and expansive gardens. Chester Congdon was an attorney who accumulated great wealth in mining and land speculation. His wife Clara was a talented artist who was involved in the design and decorating of Glensheen. In 1968, the estate was given to the University of Minnesota, has been opened for tours since 1979, and is listed on the National Register of Historic Places.

Eight

STREETCAR SUBURBS

Streetcar service began in downtown Duluth in 1883 with trolleys pulled by mules. By 1890, they were electrified and ran on tracks that stretched out to Lakeside and Lester Park near Lake Superior and on Woodland Avenue up to the Hunter's Park neighborhood. Lakeside and Lester Park also had commuter trains with six daily runs.

It was then possible to live away from the crowded commercial downtown, and so beginning in the 1890s, the suburbs of Lakeside, Lester Park, and Hunters Park flourished. The streetcar system also served residents of near downtown, because they could more easily visit parks, especially the popular Lester Park and the YMCA Park in Woodland.

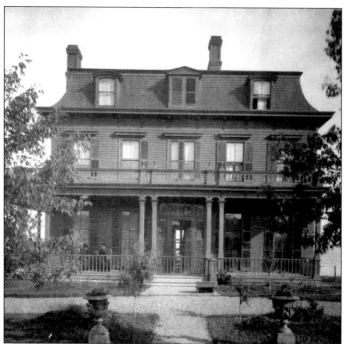

GEORGE AND MARY SARGENT HOUSE, 4440 LONDON ROAD. The Sargent house on London Road was probably built in the early 1870s, and may have been one of the first in Lakeside. Sargent was instrumental in early development of Duluth. He came to Duluth in 1869 with his wife and children, was Surveyor General for Wisconsin, Iowa, and Minnesota, built the first bank, St. Paul's Episcopal Church, and generally served as Jay Cooke's representative. The Sargent house was demolished in 1915.

FRANK AND JENNIE CLARKSON HOUSE, 4842 LONDON ROAD. The area of Duluth known as Lakeside had few homes until the Lakeside Land Company was organized and sold lots in the late 1880s. The company also employed architects who designed many of the houses. These included well-known Duluth architects Frederick German, I. Vernon Hill, and Oliver Traphagen. The Clarkson house was built about 1888 by the Lakeside Land Company and sold to the Clarksons. He was a clerk for Stone-Ordean-Wells, a wholesale grocery firm, but was later a partner in the Wright-Clarkson Mercantile Company, another wholesale grocery firm. The house is in the Queen Anne style and is a mirror image of the house next door at 4840 London Road.

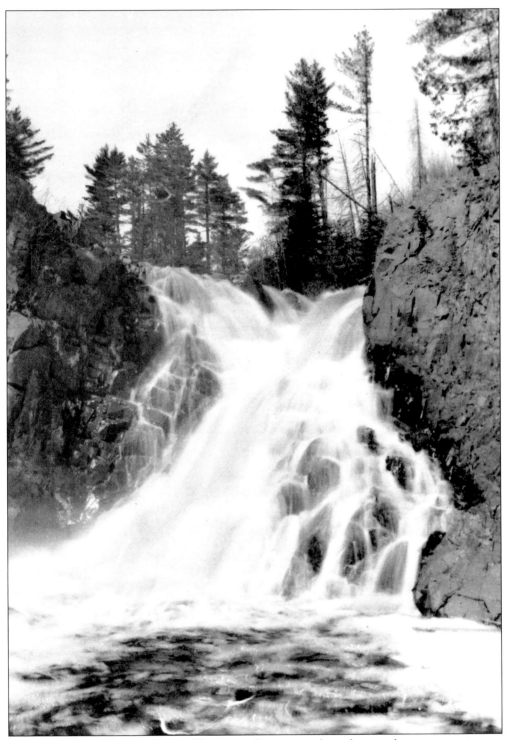

LESTER FALLS, IN LESTER PARK. The Lester River runs through several canyons on its way to Lake Superior. This 1891 photo shows the major falls which drops about 30 feet near the pavilion in Lester Park, on Occidental Boulevard.

115

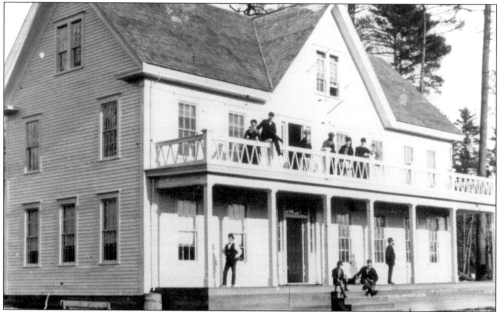

LESTER PARK HOTEL, 60TH AVENUE EAST AND LONDON ROAD. This hotel was built in 1890 near the mouth of the Lester River, by the Lakeside Land Company. Nearby railway and streetcar tracks brought visitors from Duluth to Lester Park for "excellent boating, bathing, and fishing," as advertised by the hotel. Oliver Traphagen was the architect of this plain, unadorned building. Originally called the Lakeside House, the name changed to Lester Park Hotel a year after it opened, but it was never the successful enterprise that its owners expected. It closed in 1897, and was demolished in 1902.

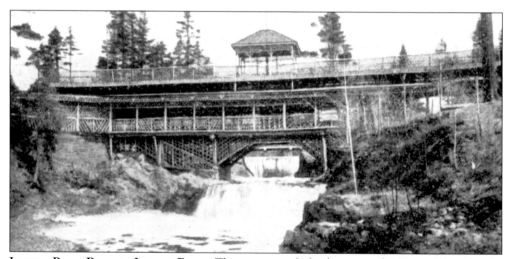

LESTER PARK BRIDGE, LESTER PARK. There were early bridges over the Lester River, but in the spring of 1896 heavy rains washed them away. John Busha, a French/Ojibwe park board worker, designed this rustic bridge near the park entrance. He and his sons Abraham and George worked all during the 1897 winter, cutting cedar and hauling it to the site. They built the bridge with two decks, the lower for crossing the river and having picnics, the upper for lounging and watching the river. In 1916, the upper deck was deemed unsafe and taken down, but the lower deck lasted until 1931, when it was razed.

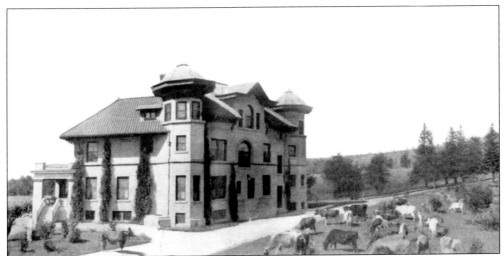

JOHN AND SUSAN SEBENIUS HOUSE, 40TH AVENUE EAST AND LONDON ROAD. John Uno Sebenius was the General Mining Engineer for the Oliver Mining Company. During the 1890s, he explored and mapped much of the Mesabi Range. About 1907, the Sebenius family built an estate called "Trianon" on London Road. It was a dairy farm of 20 acres located between 38th and 42nd Avenues East, on the shore of Lake Superior, where Sebenius conducted research to purify milk for Duluth dairies. The Sebenius home was demolished in the 1930s.

UNITED STATES GOVERNMENT FISH HATCHERY, 6008 LONDON ROAD. Also called the "Lester River Fish Hatchery" because it is located at the mouth of the Lester River on Lake Superior, it was built in the 1880s. It was constructed with the intent of raising native Lake Superior fish. The photo shows the main laboratory and the bins where the fish were reared. It closed in 1946, and became the property of the University of Minnesota-Duluth campus. The Stick style building has decorated shingles and is listed on the National Register of Historic Places.

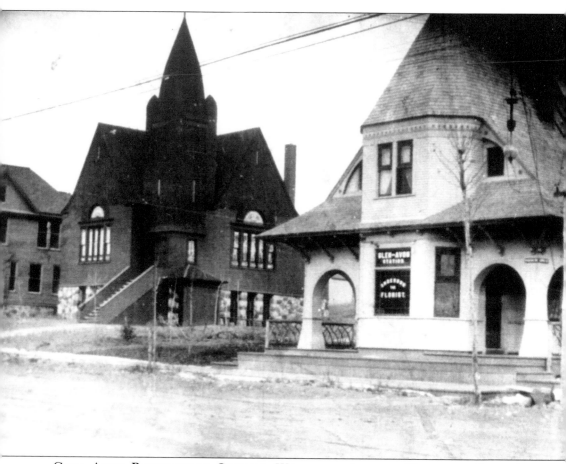

GLEN AVON PRESBYTERIAN CHURCH, WOODLAND AVENUE, NORTH OF GLEN AVON STATION. In 1893, Alexander Macfarlane donated funds for a Gothic style church for residents of Hunter's Park. By 1900, the congregation needed a new church and the present church was built across the street. This building was dismantled and moved to Gilbert, Minnesota, where it was reassembled and is still in service as a Presbyterian Church.

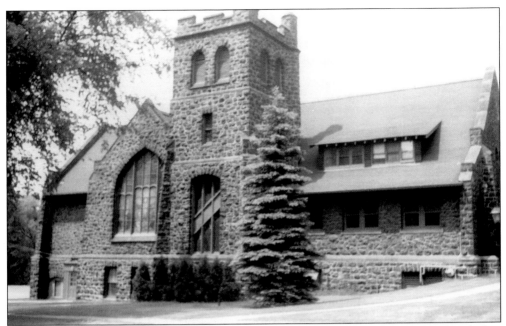

GLEN AVON PRESBYTERIAN CHURCH, 2105 WOODLAND AVENUE. This is the church that replaced the earlier Glen Avon Church, which stood across the street. Frederick German and A. Werner Lignell of Duluth were the architects for the 1909 stone, Neo-Gothic style church with a square tower and shed dormer on the roof. Members of the congregation were so attached to the old church that they kept the bell, stained glass windows, and pulpit from the old church to be used in the new.

RONALD AND JOSEPHINE HUNTER HOUSE, 2317 WOODLAND AVENUE. Ronald Hunter designed his 1892 home in the Gothic Revival style, which is a rare house style in Duluth. He and his brother-in-law Angus Macfarlane developed Hunter's Park, which is named for Ronald Hunter. The first story of the house has basalt rock which was quarried on the lot and the second story has pointed windows typical of the Gothic style on the second.

119

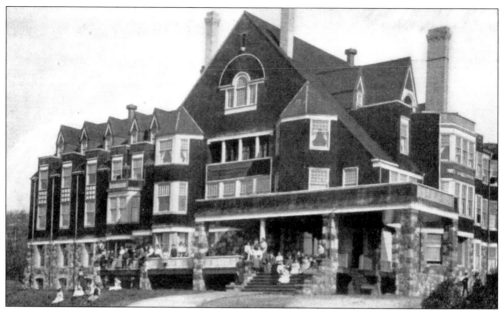

THE HARDY SCHOOL, 2000 WOODLAND AVENUE. The Hardy School was a college preparatory school for young women. It opened in 1891, and was named for the founder, Katherine Hardy. By 1895, it was called Maynard School, and from 1897 to 1902, the name had changed again to the Craggencroft School. The school was not successful in spite of the name changes and its affiliation with the University of Chicago. Traphagen and Ftzpatrick designed the building in the Shingle style with an impressive first story of local stone. Hardy School was demolished in 1905.

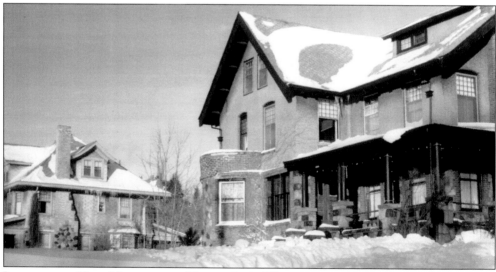

LUTHER AND KATE MENDENHALL HOUSE, 2000 WOODLAND AVENUE. When Hardy School was razed, Luther Mendenhall, a wealthy real estate investor who had married Kate Hardy, the school's founder, hired Frederick German and A. Werner Lignell to build three homes on Woodland Avenue from the school's materials. The Mendenhalls lived in the home on the exact site of Hardy School, and stone from the school can be seen on the porch and on the chimney of the house next door.

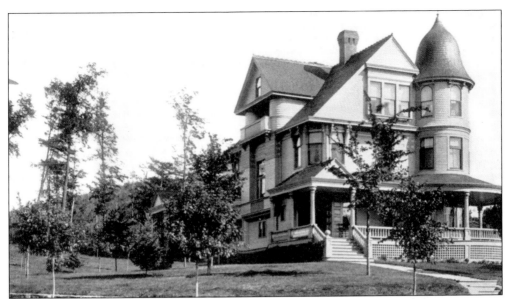

JED AND ALMA WASHBURN HOUSE, 101 EAST OXFORD STREET. The Washburn house was referred to as the "Hunter's Park Mansion," with its corner tower and porches dominating. It was built in 1892 for Arthur Holgate, who lived here just two years before the Washburns bought it and lived in it for over 40 years. Mr. Washburn was an attorney and banker. His wife, Alma, was active in public affairs which was unusual for her generation. She served as State President of Women's Clubs, and on the board of the home for delinquent girls in Sauk Center. Washburn hall on the University of Minnesota-Duluth campus and Washburn School in Hunter's Park were named for Jed Washburn in recognition of his work with the Duluth School Board and the State Normal School, which would eventually become the University of Minnesota-Duluth campus.

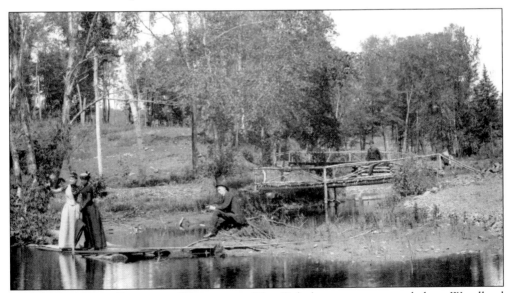

YMCA PLEASURE GROUNDS, WOODLAND. The Duluth street cars traveled up Woodland Avenue to a wooded park, on the site of present day Hartley Field. The park was a favorite picnic spot at the time of this photo in 1890.

SAMUEL SNIVELY. Although others introduced the plan for Skyline Parkway, Samuel Snively was the driving force to expand and complete the hilltop boulevard which was only five miles long in 1900. Snively was an attorney who became wealthy by investing in Duluth real estate. He built a home and farm near the Lester River, and developed Snively's Road which featured wooden bridges crossing the river. In 1921, Snively was elected mayor of Duluth and served for 16 years, constantly working to complete the boulevard. Even after the dedication of 28 miles of Skyline Parkway in 1929, Snively campaigned for improvement and extension of the scenic road, until his death in 1952.

ALONG THE BOULEVARD. In this 1897 photo, one can see the completed roadway in the western section, with the boulder-lined edge overlooking the city and lake about 600 feet above the present lakeshore. In the background, on the right, can be seen Minnesota Point. In 1891, the Boulevard was only three miles long, and by the turn of the 20th century only two more miles had been added. Today the Skyline Parkway winds its way across the hillside and Spirit Mountain for 38 miles.

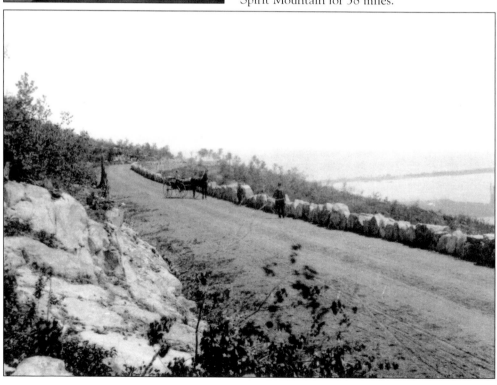

Nine

SKYLINE PARKWAY

In 1888, William K. Rogers, the president of Duluth's park board, developed a plan for a roadway near the top of Duluth's hills in the western part of the city. The first few miles were completed in 1891, and soon "Tallyho" parties began. A "Tallyho" was a single carriage or a group of carriages pulled by teams of horses along the "Boulevard," as it was then called, to view the scenic beauty of Lake Superior.

During the next 38 years, with Samuel Snively's work and encouragement, the city slowly extended the parkway, purchasing right-of-way, landscaping the drive, and building stone bridges over rivers and creeks. In 1929, at the time of the dedication and as a result of a newspaper-sponsored contest, the boulevard was officially named Skyline Parkway.

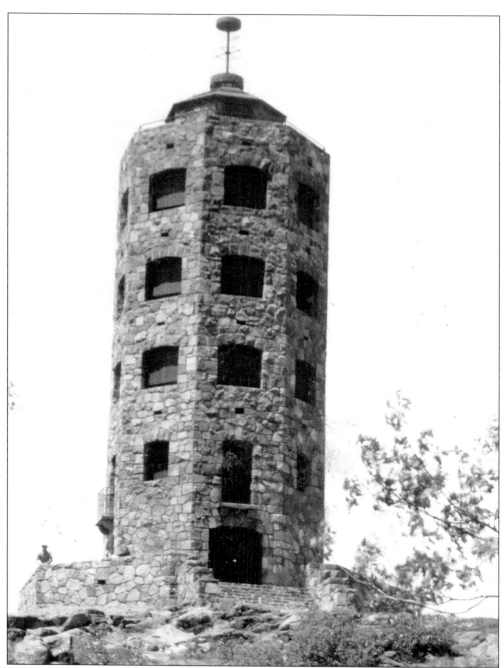

ENGER TOWER, IN ENGER PARK ON SKYLINE PARKWAY. Bert Enger, a Norwegian immigrant, established a successful furniture store in Lincoln Park (West End). He donated the land for Enger Park, and purchased the Leif Ericson replica vessel, which crossed the Atlantic in 1926. When Enger died in 1931, he left money for a memorial building at the top of Enger Park. His will stipulated that his ashes should be placed in an urn attached to the building. The City of Duluth honored his wishes and built Enger Tower, which is 75 feet tall, of native bluestone, with a spectacular view of the city, harbor, St. Louis River, and Lake Superior. Norwegian Crown Prince Olaf and Princess Martha visited Duluth in 1939 for the dedication of the tower.

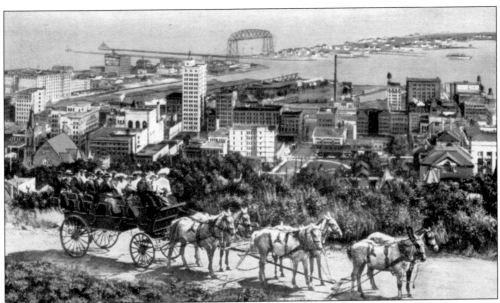

TALLYHO PARTY. This Tallyho party on the Boulevard dates to about 1910. By this time, most of downtown Duluth was filled with brick and stone commercial buildings, which replaced the early wood structures. Tallyho parties on Skyline Parkway were common for Duluthians and visitors alike, as large groups took sightseeing and picnicking trips on weekends.

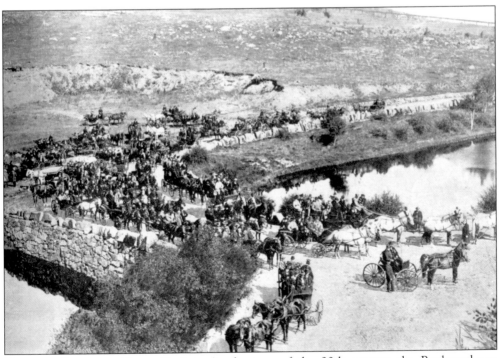

TALLYHO PARTY AT TWIN PONDS. At the turn of the 20th century the Boulevard was considered by many to be "The Most Beautiful Drive in the Country." Many weekends saw hoards of tourists and residents cruising the parkway on what was called Tallyho rides. The photo shows such a party near Twin Ponds, which is in Enger Park.

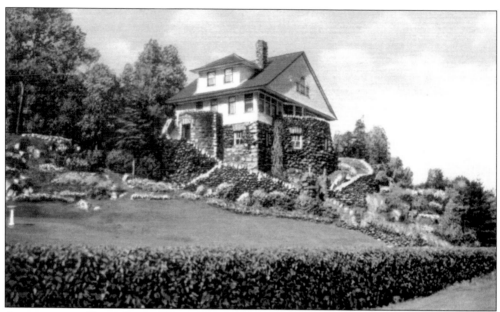

ARTHUR AND ELLA COOK HOUSE, 501 WEST SKYLINE PARKWAY In 1900, the Cooks commissioned young architect I. Vernon Hill to design their home on a steep, rock-filled lot, which has a spectacular view of the Duluth Harbor and Lake Superior. The Cook home, with its extensive gardens, was often cited as the most photographed house in Duluth. Cook was a druggist who served as superintendent of the county poor home, later named the Cook Home in his honor.

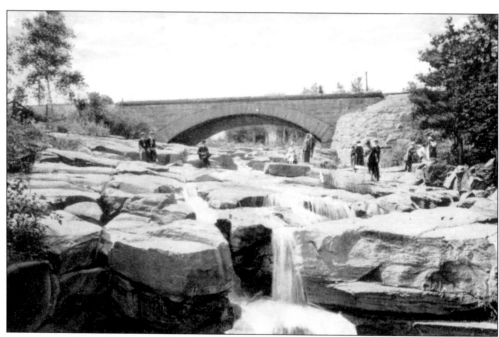

FAIRMOUNT PARK. Kingsbury Creek is one of the many creeks cascading down the hill to Lake Superior. The creek is directly above the zoo and an abandoned bridge crosses it, which during the time of this photo was part of the Skyline Parkway.

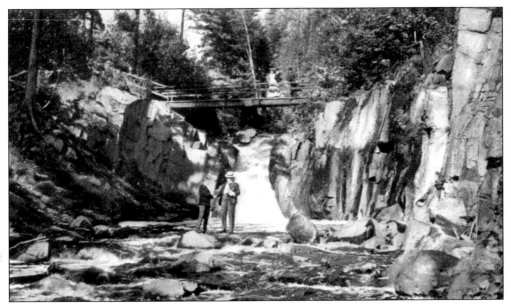

CHESTER FALLS. Chester Park, located in Duluth's east end, follows the flow of Chester creek. The park was acquired by the city in 1891, with additional acreage added in 1923. The park and creek were named for Charles Chester, an early settler who built a cabin on the creek above Fourth Street.

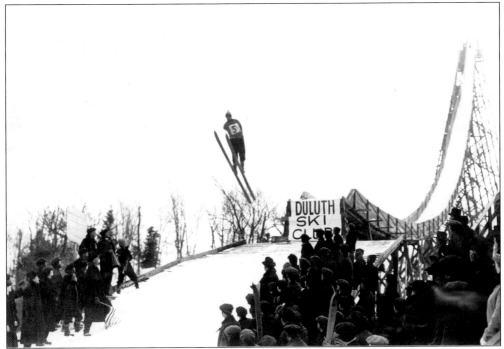

CHESTER PARK SKI JUMP. The Duluth Ski Club was organized in 1905, and in the following year a Duluthian won the national championship. Several early slides were built in Chester Park and this was one of the earliest, built before 1910. In 1924, the world's largest steel slide was built here, and by the 1930s, Duluth was known as the "Ski-jumping Capital of the United States."

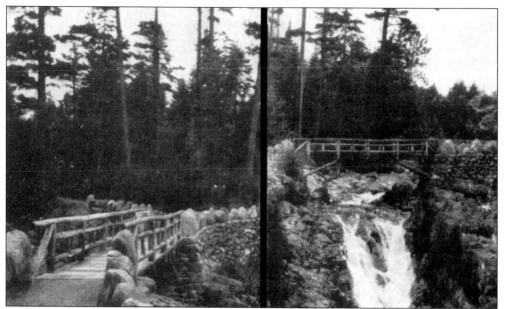

LESTER RIVER. These photos were taken along Seven Bridges Road, which follows the Lester River up the hill from Lake Superior. It is believed that the name "Lester" came from an early pioneer who lived at the mouth of the river, where it empties into Lake Superior. Lester River runs through Lester Park and has several deep gorges and spectacular falls.

SEVEN BRIDGES ROAD, NEAR 60TH AVENUE EAST AND EAST SUPERIOR STREET. This is one of the stone bridges spanning the Lester River near the east end of the Boulevard. They were designed by landscape architects Morell and Nichols of Minneapolis and built in 1910 and 1911.